PAUL CALLE
AN ARTIST'S JOURNEY

FOREWORD
Ginger Renner

THE ARTIST'S JOURNEY
Pam Hait

JOURNEY INTO SPACE
James Dean

Mill Pond Press
Venice, Florida

Published by Mill Pond Press, Inc.
310 Center Court
Venice, Florida 34292-3500 U.S.A.
800-535-0331

Copyright © 1992 Mill Pond Press, Inc.
All artwork copyright © 1992 Paul Calle
First Edition 1992

ISBN-0-941728-04-8
Library of Congress Catalog Number: 92-62400

The publisher gratefully acknowledges the following
sources for material contributed to this book:

Details of maps courtesy of: Oregon Historical Society,
#Or.H.87379 (front) and Nebraska State Historical
Society (back).

Permission to reprint copyrighted artwork courtesy of: *The
Saturday Evening Post* © 1968 (p. 18); *TIME* Magazine
© 1971 Time Inc. (p. 19); *Great People of the Bible* © 1974
by The Reader's Digest Association, Inc. (p. 24); The U.S.
Air Force Historical Art Collection (pp. 25, 44-right); U.S.
Postal Service (p. 29); Schering Corporation (p. 45-top
right); National Air and Space Museum, Smithsonian Insti-
tution (pp. 51, 58, 59, 60, 61, 62, 65, 66); NASA (pp. 53,
54, 56, 57).

Photographs courtesy of: *The News Times*/Carol Kaliff
(pp. 14, 34); Ellen Pedersen Collard (pp. 15, 16); the Calle
family (pp. 23, 35, 37, 40, 49, 55); Norman R. Lightfoot
(pp. 27, 28, 31, 32, 33-right, 35-bottom left, 36, 41);
Ted M. Moews (p. 33-left), Ellie Deuter (p. 30);
Paul Burdette (p. 38-left); Buckeye Blake (p. 38-right);
Ron Buckley (p. 39); NASA (pp. 50, 69).

The following quotes were reprinted with permission:
Astoria by Washington Irving, Binford & Mort Publishing
(p. 12); Frank Getlein (p. 54) and Hank Burchard (p. 63)
© 1963, 1989 *The Washington Post*; excerpt from "A
Reflection: Riders on Earth Together, Brothers in the
Eternal Cold" by Archibald MacLeish, copyright © 1968
by The New York Times Company (p. 68); excerpt from
Journal of a Trapper [1834–1843] by Osborne Russell, Uni-
versity of Nebraska Press, publisher (p. 115); excerpt from
"The Road Not Taken" from *The Poetry of Robert Frost*
edited by Edward Connery Lathem, copyright 1916,
©1969 by Holt, Rinehart and Winston, copyright 1944 by
Robert Frost, Henry Holt and Company, Inc., publisher
(p. 41).

Page 1
Detail from *And A Good Book for Company*,* oil, 22" × 29", 1985

Pages 2-3
Just Over the Ridge,* oil, 30" × 48", 1981

Page 5
Detail from *Something for the Pot*,* oil, 30 ¾" × 42", 1980

Page 6
When Trappers Meet,* pencil, 28 ¾" × 38", 1992

Page 8
Navajo Madonna,* sanguine, 22 ⅝" × 14 ⅞", 1989

Page 9
Olga and Claudia, sanguine, 19" × 15 ¾", 1955

Page 10
Detail from *In the Land of the Giants*,* oil, 38" × 52", 1987

Page 13
Paul Calle Self-Portrait, pencil, 7 ½" × 5", 1984

Pages 46-47
Detail from *The Great Moment*,* oil, 4' × 8', 1970

Page 71
Detail from *And Still Miles to Go*,* oil, 38" × 41", 1980

* See page 150

Contents

The publisher would like to thank the following people, whose encouragement, support and generous assistance helped make this book possible: James Dean, the Lewin family, Frank McCarthy, Robert McCall, Ray Swanson, Michael Collins, Mrs. H. Lester Cooke, Jack Williams and the Calle family.

This book is dedicated with love to Olga, who, for all these years, has shared the hopes, the dreams and the realities and continues to believe in the words of Robert Browning "...the best is yet to be, the last of life for which the first was made..."

The journey has just begun.

Foreword

BY GINGER RENNER

THERE WERE GIANTS IN THE LAND, but even the eldest of the elders cannot remember seeing them. We know they strode across the land, traversed the rivers, followed the waters upstream and, finally, trudged the creeks, reaching farther and farther into the massive wilderness of the Rocky Mountains. Their footprints have been blown away with the autumn winds, the trees they blazed have been felled or struck by lightning or rusted by the spruce beetle. The snows and rains have washed out their thousand campfires, and their occasional lost cache has been buried under the accumulated debris of more than 150 years. There is almost no physical evidence left that they passed this way. Sometimes, even today, a prospector or a straying hunter or a mountain climber will run across a crumbling cairn of rocks, long pilfered of whatever was stashed for safekeeping. If they thoughtfully return the fallen rocks to the original mound, do they muse over the first builder? Was it Colter or Drouillard? Did the Spaniard, Manuel Lisa, in his years of assault on the Missouri and its myriad of tributaries stop here to cache some ammunition? Perhaps it was one of the ebullient Scotsmen, Donald MacKenzie...or did Bridger or Kit Carson come this way? Was this cairn first raised by one of the nameless *coureurs des bois*, runners or rangers of the woods—that wandering breed of Frenchmen who, according to the early 19th Century author, Washington Irving, "became so accustomed to the Indian mode of living and the perfect freedom of the wilderness that they lost all relish for civilization, and identified themselves with the savages among whom they dwelt, and could only be distinguished from them by superior licentiousness!"

As our rebuilder moves on, does he think of that remarkable confluence of men who spilled out across the vast prairies from Hudson's Bay westward to the shining mountains or embraced the challenge of piercing the passionately held territory of the Teton Sioux? Does he recall those men whose names should ring out over the mountain peaks of the Rockies: Pierre Dorian, Andrew Henry, James Clyman, Jedediah Smith, Hugh Glass, William Sublette, Jim Beckwourth and the Bent brothers, Charles and William?

Does our lonely traveler into these still vast and often untracked mountains dwell on the incongruity of large groups of his contemporaries lamenting the impending loss of the snail darter or freely giving of their time and talents to bulwark the tenuous existence of the California condor or even committing felonious acts in order to call attention to the Northwest's spotted owl, which has come to be a metaphor for endangered species? Yet few of these stop to contemplate the total demise of a species of men who were giants in their time and whose legendary prowess, courage, ingenuity, skill and ability to survive in the harsh and demanding world of the Northwest territory still elicits awe and wonder.

The inexorable tide of emigration moving westward washed over the virgin land of the fur trappers, bringing to a close one of the most colorful, as well as successful, periods of our history. The very success of the fur traders doomed their prospects. The beavers, the prime source of whatever financial success came to the fur trade, became scarcer. The trappers, the *voyageurs* (boatmen), the *engages* (engaged or

employed), the *coureurs des bois* all had to struggle further up dwindling streams, settle for fewer and fewer pelts, padding out their season's catch with raccoons and buffalo. The increasing threats and thrusts from native tribes, wary of so many white men spilling over their hunting grounds, coupled with the diminishing harvest, rang the death knell for a unique enterprise which enjoyed considerable success and which made major contributions to the young Republic, providing invaluable information on the land, the waterways and the natives who would be encountered on the way to opening the wilderness country.

How often we have been indebted to artists for preserving an endangered species or even one which has totally disappeared. How much poorer our world would be had not George Catlin had a vision about the inevitability of change among the tribes of the high plains and set about to capture these people on paper and canvas.

The itinerant cowboy of the trail drive and the open range lasted little more than 20 years, but Charles Russell, in a huge body of oils, watercolors and drawings, preserved the cowboy's prowess, daring, his extraordinary skills with horses and cattle and the *joie de vivre* he brought to his "profession."

In later years, other artists have saved some of the earth's most endangered species on their canvases. Their breathtaking images serve as a rallying cry to the world, warning all of us of the tenuous position of the black rhino, India's white tiger or the African elephant, all creatures of such magnificence it is unthinkable they could be erased from earth.

For more than twenty years now, Paul Calle has been devoting himself to painting another lost species—the fur traders and mountain men. Lovingly, and with consummate skill, he has recreated these giants in the richness of the land which was their domain—and few artists are more qualified to do so. In the fulsome

years of his career, Calle has been breathing life anew into men who reflect the admirable characteristics of Old Bill Williams, Peter Skene Ogden, Joe Meek and the men of the remarkable Chouteau family.

Calle's fascination with the history of the opening up of the Northwest wilderness has produced a great body of dramatic, arresting oil paintings and complex and richly defined drawings, allowing us to know once again these intrepid adventurers. Another generation will come to admire their abilities and inventiveness and yes, perhaps, to secretly envy the sense of freedom that marked the breed.

A giant step had to be taken to move away from the subjects with which Paul Calle had been so successfully involved. For almost a decade, Calle had been one of eight internationally recognized artists tapped to record and preserve the men on the cutting edge of infinity, the astronauts of our space program. His association with these young men with the "right stuff" was so successful that when the time came to memorialize one of the culminating events of this great space adventure, the landing on the moon, Paul Calle drew the assignment—and went on to make artistic history.

How easy it would have been to continue to devote his multiple talents to the astronauts and the challenges of probing space. Calle finds remarkable correlations between the men of the late 20th Century blasting into space and the men of the early 19th Century slogging their way to glory up the Missouri. The transition from recording and documenting the astronauts to bringing back into reality the men of the fur trade was embraced with great enthusiasm.

So complete has been Calle's immersion into the history of the trappers, traders and their native partners in the fur trade that the artist has come to resemble his artistic subjects, in particular, the *coureurs des bois* he favors as models.

The mountain men were multi-cultural: French, half-breeds, Scottish, English and American. Calle seems partial to the half-breed as a subject for his dramatic oils; they are sufficiently French to have a tone of their own. Washington Irving, in his 1836 book, *Astoria*, says of them:

They are generally of French descent and inherit much of the gaiety and lightness of heart of these ancestors, being full of anecdote and song and ever ready for the dance. They inherit too a fund of civility...and, instead of that hardness...which men in laborious life are apt to indulge towards each other, they are mutually obliging....Their natural good will is probably heightened by a community of adventure and hardship in their precarious and wandering life.

The artist brings such an understanding of these men, such an appreciation for their way of life to his large oils that it is apparent he has a highly satisfactory emotional commitment to this vibrant historical period.

Standing before a Calle drawing is akin to standing before a magnificent Gobelin or Beauvais tapestry...the warp and woof are apparent in the highly textured surface. The rich complexity of Calle's recreation of virgin wilderness intrigues the viewer. We know the roughness of smoke-and-grease-hardened buckskin worn by a man easily resting his hands on a Hawken rifle...we long to reach out and touch the softness of down on a Canada goose that will serve as supper for the lone adventurer.

As witnesses to Calle's consummate skill, we say to ourselves, "Yes, this is the way it really was...this was real."

And once again, there are giants in the land.

The Artist's Journey

A Profile by
Pam Hait

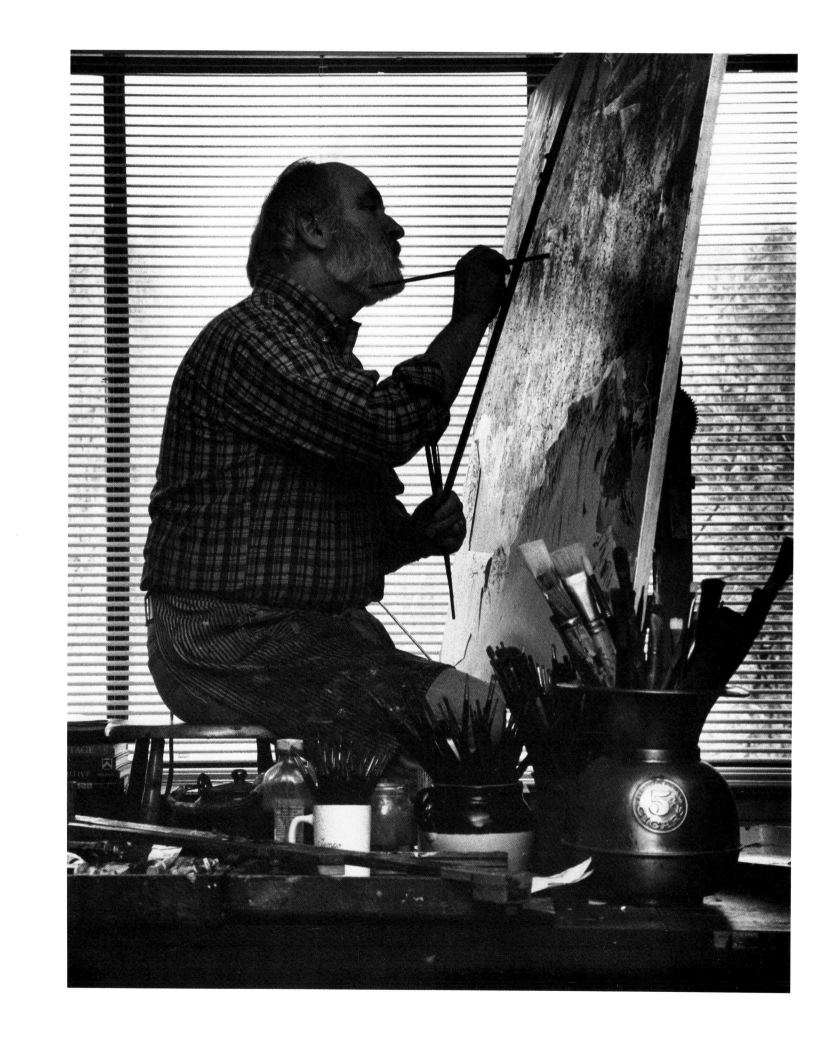

IN RETROSPECT

As he dressed for the evening, artist Paul Calle smiled across the hotel room at his wife, Olga. Neither verbalized their thoughts. After 40 years of marriage, they didn't have to. Each thought back to the night, nearly 20 years ago, when they had dressed for a similarly significant affair. On that evening long ago, he had said to her, "What do you think we should consider a success?"

And Olga, ever the pragmatist, had replied, "If we sell one or two paintings, I think it would be wonderful."

They sold out in the first half-hour of that show. It was the beginning of his illustrious career chronicling the Western experience.

Now, there was no time for reminiscing. On this warm June evening in 1991, 600 people gathered in the galleries of The Thomas Gilcrease Institute of American History and Art in Tulsa, Oklahoma. The occasion was a 25-year retrospective of Calle's artwork.

"Earlier that morning, unable to contain myself any longer, I slipped away to view this exhibition. I wanted to spend some time alone with my work. And as I entered the silent gallery and saw examples of my work spanning the past 25 years, I realized that I was not alone, for there, on the walls, were my creations—my children, if you will—my family. I knew then that I was not alone, and it felt good," said Calle.

As the Calles entered the museum, one could feel the love and admiration in the air. Within moments, they were surrounded by collectors and would-be collectors, old friends and the press. Olga, elegant and gracious, listened intently and made each person feel remarkably special. Calle, with his commanding presence, easily took center stage. Surreptitiously, he scanned the gallery for his grown children and their spouses. This was Calle's special night, and, in typical style, he gathered his family around him to share the glory.

An excited hum built as the crowd explored the impressive body of Calle's work. Never before had

Paul and Olga Calle, March, 1992.

Calle at the opening of his Gilcrease Retrospective, discussing plans for future works with collectors, June, 1991.

space, while other rooms exhibited what Calle calls his "Western experience." These masterful drawings and commanding paintings cover a wide swath of Americana from Native American rituals to the hardships endured by those who lived the fur trade.

As a NASA artist, Calle chronicled the Mercury, Gemini and Apollo missions. As a Western realist, he envisions American history. Asked how he reconciles these disparate subjects, he answered smoothly, "Although it may be difficult to compare what seems like light years apart, there are similarities. I like to use the analogy of the oneness that I see between Neil Armstrong's boot sinking into the dust of the moon and the moccasined foot of a man like John Colter sinking into the snow as he entered the Yellowstone River Valley for the first time."

Standing before his enormous painting of Neil Armstrong setting foot on the lunar surface, *The Great Moment* (pp. 46-47), Calle was again stirred by the space program's unique achievement. His wonder remains pure.

"Looking at the drawings and paintings, memories associated with individual pieces raced through my mind—the euphoria I experienced in 1969 at being with the crew of Apollo 11, Armstrong, Aldrin and Collins, the day they left earth for their historic journey to the moon. Looking at the sketches executed that morning of the suiting up procedure brought

this artist mounted a retrospective. Not that he hadn't been asked. The late Fred Myers, then director of The Gilcrease Museum, had repeatedly invited Calle to put on a retrospective at the Museum, but the artist had not felt comfortable committing to a show of that magnitude. A retrospective is an involved process; collectors must be contacted, pieces borrowed and new material prepared. All this consumes valuable time and energy. Once he agreed to the show, however, Calle was determined to arrive in Tulsa with nothing but his best. Consequently, when "Rendezvous 1991" opened, it was an extraordinarily complete assemblage of Calle's life's work. In addition to his existing drawings and paintings, he produced nine new works for this exhibition, including

the monumental oil painting, *When Trails Grow Cold* (pp. 146-147).

"To have all these pieces here, hanging in this magnificent museum, is an enormous honor and pleasure," Calle commented to an admirer. "You know, there are things here I haven't seen in 20 years, and I am thrilled to see them again." Calle's enthusiasm was nearly beyond containment.

To understand this artist's universe is to understand that it is rooted in his family and floats in an orbit stretching from outer space to the historic West. It is a landscape bounded by a single theme—the frontier. For this occasion, one large gallery was hung with pencil drawings and oils from his years as a NASA artist, a series rich with the drama of the race to

back all the excitement of those days when the people of the earth were truly one—the countdown, the ignition of rocket engines, the roar of the liftoff—and they were on their way to history. To add to my excitement, I was on the journey with them, for they were carrying to the surface of the moon the stamp which I designed to commemorate that historic event. It's difficult to find words to describe my feelings then—it was unbelievable, fantastic and incredible—all at once." Calle's arresting and sensitive space interpretations brought the space adventure home. While other artists captured the technical detail, Calle concentrated on the passion of this singular journey.

Calle says he is enormously proud to be called a visual historian. "Will my work live? While that's not for me to say, I do believe this body of work will live on in history—not because of me, but because of the subject matter."

By all but architectural standards, the size of Calle's work is daunting. "I believe in painting big," he acknowledged. "My subjects demand it. Space and the West are vast. They cannot be contained in small framed areas."

During the Gilcrease dinner, Calle and his wife chatted happily with their friends and collectors. He conveyed his delight that the Gilcrease had

commissioned a drawing for its permanent collection years ago. "At that time, when I saw *The Landmark Tree* (p. 85) hanging between a Russell and Remington, I was so excited I almost didn't want to leave the room," he confessed.

As is true at every Calle exhibition, the competition to purchase his drawings and paintings was keen. When the Gilcrease show concluded, most of the work was sold. Once again, people showed how much they appreciate his art.

1991 marked another milestone for the Calles as three generations gathered to celebrate the couple's 40th wedding anniversary. Shown left to right are: Ellen and Paul Peter Calle with son Paul Richard, Olga (with grandson Nathaniel Paul Beal), Paul Calle, Sheila and Chris Calle (with nieces Katherine and Elizabeth Calle), Claudia Calle Beal with husband Ron.

FULL THROTTLE

WHEN PAUL CALLE WAS BORN on March 3rd in 1928, his young mother and father were overjoyed. His father, Peter, was a Basque fisherman, and his mother, Katherine, was a lovely Ukrainian seamstress. During their courtship Peter discovered that Katherine, who worked as a finisher in the garment district, was extremely proud of the perfection of her work. Katherine, in turn, discovered that Peter, despite his rugged occupation, was sweet and gentle and exhibited an occasional streak of whimsy. After marrying, they had settled in the Lower East side of New York City.

Confident of his artistic and intellectual abilities, the fisherman's son lives life at full throttle. In addition to a congenital defiant streak, Calle exhibits a legacy of passion and independence sheathed by a strong sense of family. Like his ancestors, the Basques and Ukrainians, he is quick to defend his rights if he senses a real or perceived threat to his work, family, or a concept he embraces. Within moments, his disposition can swing from ecstasy to anger as he unleashes the full force of his emotions.

Even from a young age it was clear that Calle was destined to be different. Surrounded by his mother's fair-skinned, blond family, Calle was dark-haired like his father. "Knowing I was different became a positive force in my life," he acknowledges. "Perhaps that's where my competitiveness came from. I certainly didn't look like the rest of my family." Considering his statement, the artist smiles broadly. "Well, Ukrainians love their kids to be different. And I was."

The artist inherited another of Peter Calle's passions, baseball. Like many boys in his neighborhood, Calle committed major league players and statistics to memory and spent hours playing ball. Father and son built a rapport based on love and shared interests. They cemented their relationship with activities like fishing, ball games and flying kites from the rooftop of their brick apartment building.

In addition to baseball, Calle also exhibited a second, and even more significant obsession, art. In kindergarten, he vividly remembers drawing on blackboards with colored chalk. Once he could read, he was mesmerized by the illustrations in children's books. By the time he was 14, Calle was a regular at the used bookstores on Fourth Avenue where he poured over wood engraving illustrations in the books he discovered. "Although I have no memory of that first moment when I started my own 'drawings,' my parents told me it was quite early in my development, and I am conscious of drawing from the age of seven. I loved it and needed no urging. My parents and older brothers encouraged me and cheerfully provided the necessary materials." While some boys grew up with stars in their eyes, Calle grew up with graphite on his fingers.

Soon the young boy could easily identify the distinctive work of the person who was to become his favorite wood engraving artist, Lynd Ward. Although he was not consciously aware of his intent at the time, Calle memorized the flow and patterns in Ward's illustrations, storing images in his mind of

Calle's cover design for The Saturday Evening Post, *September, 1968.*

trees and leaves, sharply etched lines and powerful negative space for future reference. Much later, when Calle launched his commercial art career, he produced advertising and science fiction assignments done in scratchboard. He was attracted to the black-and-white technique, similar to engraving in style and feeling, because of his association with wood engraving.

When he turned to fine art, Calle continued perfecting techniques he had utilized in his illustration career. His finished black-and-white pencil drawings, comprised of carefully controlled lines powered by strong directional flow, are notable for a forceful sense of design characteristic of engraving. The artist openly acknowledges this connection. In his book, *The Pencil*, he points out that wood engraving, more than any other technique, influenced the technical direction his drawings eventually exhibited. Engravings inspired him to draw with pattern which, the artist explains, adds dimension to an otherwise flat surface.

In addition to being gifted artistically, Calle was also a straight "A" student and skipped several grades during elementary school. Anxious to study art, he enrolled in Straubenmuller Textile High, which proved to be a turning point for the accelerated student. There he met remarkable teachers who became the major influences in his life.

His art teacher, Mr. Siegel, was a tall, slim man with dark curly hair and an amazing ability to challenge students. Calle remembers him with great affection.

At 15, Calle graduated from high school and was anxious to start his art career. His parents had hoped he'd choose a more traditional path, like engineering, but Mrs. Connery, head of the art department, intervened on his behalf and reassured the Calles that their son would never have a problem earning a living

as an artist. "To immigrant people, teachers were like God," Calle says. "They listened to her."

After graduating from high school, he answered an ad for an apprentice errand boy at a commercial art studio. Always serious about his art, Calle knew it was vital to get his foot in the door—even if only as an errand boy. New York in the 1940s was a city filled with great illustrators. An apprentice could be in line for an eventual studio job. Meanwhile, there were errands to run, bowls to clean and professional commercial artists to observe.

When he received a scholarship to the Pratt Institute of Art, Calle was ecstatic, but he worried about losing his place at the studio. A salesman counseled the young apprentice not to leave. A successful artist, however, took the boy aside. "You have the potential to be a good artist, but art training is important. Go to school and learn," the artist admonished.

The 16-year-old, an unprimed canvas eager to accept wisdom, technique and life experience, arrived at Pratt. He had never been in a life drawing class and now faced a nude woman model. It was a challenging moment. "In many ways, I was mature for my talents, but in other respects I was a child," he admits.

Even at Pratt, Calle was different. Young for college, he was unusually youthful since many of the students were returning GIs, home from World War II. Talented competition was fierce. He compensated by throwing himself into his work.

"I remember my years at Pratt with great fondness," says Calle. "Many of my fellow students remain treasured friends today. We see each other regularly and continue to share thoughts, ideas and our passion for art. The memories and influences of so many wonderful teachers also remain with me to this day. All of my life, I have been fortunate to have friends and teachers who knew when to hug me, when to push me, when to cajole me and when to encourage me.

Calle's cover portrait of George Meany for TIME *magazine, September, 1971.*

Life has treated me with great gentleness, and I am very thankful."

Anxious to emulate his idol, woodcut artist Lynd Ward, Calle concentrated on mastering scratchboard. Like Ward, he strove to convey a full range of emotions in black and white using positive and negative space, pattern, flow and design.

The youth succeeded amazingly well. In 1944 he produced a black-and-white piece, *Boy With Ducks* (p. 42), in which a boy strides by with a rifle over his shoulder and ducks at his feet. A leafy tree completed the composition—an image destined to become a major theme in his work in later years.

Pratt was a time for Calle to absorb and experiment. Here he discovered the Depression era paintings of Thomas Hart Benton and the seductive flow

A preliminary pencil study of John F. Kennedy, 1966; a completed drawing showing the President in the Oval Office appeared in the 1967 book, The Living White House.

of Ben Shahn. He completed a large oil in Benton's style, called *Sharecropper*, using his mother as a model. During this phase, Calle painted with darker values and composed large figures reminiscent of Benton.

His Ben Shahn period was more significant. Although he never met Shahn, Calle was heavily influenced by him and worked in that style from 1944 until the early 1950s. During this time, Calle elongated his vertical lines, curving them to accentuate flow and emphasize the abstract quality of design. His palette lightened, and his landscapes and portraits reflected Shahn's distinctive hand. One was so similar to Shahn's style that Calle signed it "Ben Shahn Calle."

If art was his primary passion, baseball ran a close second. In elementary school, the small, chubby child had been picked last for teams. Now tall and slim, he played catcher for Pratt and, to his father's delight, hit a game-winning homerun with his father in the stands. His art teachers were less thrilled with young Calle's prowess. One day, watching him snatch hard, fast balls out of the air, a teacher hollered, "Calle, are you going to be an artist or a baseball player?"

"Both!" the young athlete/artist replied.

There was also room in his life for yet one more love, a bright, blond girl, Olga Wyhowanec, who lived on the first floor of Calle's building. His family was on the third floor. The two had known each other almost all their lives, and when they turned 16, began to date. Her parents, who had immigrated to America from Russia, approved of their daughter's choice, and

by the time she turned 18, Olga knew she had found her soulmate.

As their relationship deepened, it turned to love. After graduating from Washington Irving High School, Olga continued her education at business school while Calle finished Pratt. Then she worked as a bookkeeper in the City. They saw each other on weekends, riding bikes through Central Park, walking along Riverside Drive and on the George Washington Bridge, talking and talking. Early on, the couple learned to make time for each other so they could share their hopes and dreams.

Sadly, when Calle was still young, his father contracted tuberculosis and remained ill for many years. Then in mid-life, he was stricken again, this time, with cancer. Peter Calle died at the age of 48 when his son was just 19.

The Pratt graduate landed a job at Harlan Crandall commercial art studio. It was 1947 and the 19-year-old assumed he was hired for his talent. When the first paychecks were issued, Harlan confessed he hired Calle because he thought Calle was Irish, that his name was Paul Kelly. "But you're doing good, so you can stay," the older artist announced.

Confident he could support a wife, Calle proposed to Olga in 1950. They met for lunch and walked to Tiffany's, where they selected her ring. She chose a platinum setting—which she has never changed—and they set the wedding date for a year later.

Two determined individuals, young and in love, the Calles were certain they could take on the world. In choosing each other, each made the other whole. He, gregarious and volatile, found a serene partner to even out his highs and lows. Where he is passionate, she is pragmatic. Where he is intense, she is serene.

With their contrasting personalities, Olga and Paul Calle appeared to be painted from two different palettes when they took their vows in 1951. Those who knew the pair, however, recognized that they shared identical values. Both children of immigrants, each cared deeply about family, and each had a drive to succeed. Like a delicate underpainting, these values imparted a cohesiveness of spirit and purpose to their life together which helped nurture them as individuals and as a team.

More than 40 years later, they remain deeply in love. Partners in every respect, each is a strong individual who respects the other's opinions. Recognizing differences, however, doesn't always result in agreement. Olga is no pushover; Calle can be stubborn. Yet, more often than not, after spending his emotions, the hot-tempered artist bows to his wife's calmer perspective. He is the first to concede that "Olga-the-Good," as he calls her, "was born wise."

Their children also value their mother's approach to life.

Their first child, Claudia, sums it up eloquently. "My mother lives with dignity and grace," she says.

"My father doesn't call her St. Olga for nothing," adds their youngest child and second son, Chris.

Olga smiles at these testimonials from her family but accepts little credit. "I am even-tempered by nature," she insists, "but I do get what I really want." Ever the bookkeeper, Olga has always handled the business of Calle's career, a role she enjoys and performs efficiently. Her husband says, only half-facetiously, "She's not allowed to die before me because she knows everything, and I would be very confused."

Before their wedding, Calle was drafted for the Korean War. He had been too young to serve in World War II and now was older than most of the men being called up.

When he heard someone was needed to do lettering at Fort Dix, New Jersey, he volunteered. No matter that he had no brushes. He went outside, cut some green branches, and made his own. From then on, he worked as an artist from a studio he set up at the end of a long, narrow barrack. Quickly, Calle established his artistic credentials.

After completing his basic training, Calle was assigned as an artist to a Special Service Unit at Fort Dix. His duties included illustrating training manuals, posters, charts and maps. Evenings were spent drawing and painting. After receiving several awards in Army sponsored worldwide art contests, he volunteered to go to Korea as a combat artist.

"The memories of seeing so many drawings and paintings by World War II combat artists inspired me to attempt to emulate them," says Calle. "My assignment to Fort Dix was 'frozen' while awaiting orders to serve in Korea, but the orders never came because the combat art program was eliminated."

Calle then requested Germany. Again, no action. Instead of serving as a combat artist, Calle remained at Fort Dix for two years.

After he was discharged in 1953, the couple moved to Flushing, New York. Olga worked in the City as a bookkeeper; he freelanced and maintained a small studio on 32nd Street near Broadway, paying $29 a month for the space, including electricity. It was small, but it was all his. His brief stint at the Harlan Crandall agency convinced him never to work for anyone again.

Calle was eager to compete. Although he had rapidly advanced through school and never waivered from his intent to become an artist, here was his opportunity to prove himself in the world of New York illustration. He knew no shortcuts to success existed. An artist had to be ready for any assignment and then do his utmost to beat the competition and please the client. Ambitious and talented, Calle was anxious to measure himself against the best.

He was thrilled to land an assignment for a full-page drawing for *Collier's* magazine and worked quickly to complete it. Proudly, he delivered his finished drawing to the advertising agency. When the art director accepted the assignment, he was impressed by Calle's work and correctly surmised that the young artist didn't have an agent. He suggested Calle make an appointment with Frank Lavaty, the top agent in the business. Calle hesitated, saying he was just a little artist, and Lavaty was a huge name.

"Go see Frank," the art director reiterated.

That evening, after Calle repeated the conversation to Olga, she quietly suggested, "Maybe you should start at the top."

The next day, he called Lavaty to request a meeting. When the day arrived, Calle anxiously appeared at Lavaty's office, clutching his portfolio under his arm. The artist had culled his best work to show a wide range of styles and subject matter. He knew that a good illustrator drew it all—science fiction to coffee pots to portraits—and he did it fast.

The artist was nervous as Lavaty examined the portfolio. Finally, the agent gave his verdict. Regretfully, he informed the artist that his samples weren't quite good enough for Lavaty's clients. The agent

was looking for a certain commercial quality that was missing in Calle's work. Besides, he added, "I really don't think you will ever become a successful illustrator. I have a feeling that some day you will be a fine artist."

Calle took on Lavaty as a personal challenge. By day, he worked on his own accounts; at night, he prepared new samples for his portfolio. During the next few months, he kept in touch with the agent, apprising him of his progress. When Olga became pregnant with their daughter, Claudia, Calle called Lavaty again. This time Lavaty responded positively and assigned Calle one of twelve paintings for the Esso (now Exxon) calendar. Later, Lavaty admitted he had given Calle a false deadline because he didn't think the young artist could handle it.

Gratified finally to be at bat, Calle was determined to get a hit. He smacked a double. Not only did he deliver his painting first, his was the only one requiring no changes.

Out of that assignment, a solid relationship evolved between the outspoken artist and the agent with the twinkle in his eye; their partnership lasted 20 years, and Calle became known as "the guy who solves jobs."

As his reputation flourished, the artist accepted a wide variety of commercial assignments. Nine-tenths of them were done in black and white. Out of his early love for woodcuts grew his distinctive drawing style, an intense explosion of gray-to-black lines in which the directional flow always follows form. His pencil drawings became his calling card. Whether depicting a President of the United States, a ring for

a jeweler's newspaper advertisement or a huge, gnarled tree, Calle didn't vary his signature style.

During his successful commercial career, the artist covered humor to realism with an increasing emphasis on historic subjects. The range challenged the intelligent artist who enjoyed researching subjects to devise illustrative solutions. When he was chosen as the official artist for the World Series for two years in a row, he hit another double—combining baseball and art in one swoop. His *Saturday Evening Post* assignment, "Great Moments in Sports" and "Great Moments in the History of Surgery," (p. 45) commissioned by Schering Corporation, garnered commercial and critical acclaim, and Calle began to realize that interpreting history was yet another of his passions.

Early on, the artist developed a unique method for working with his commercial accounts. Having witnessed art directors and clients rejecting art by saying, "This isn't exactly what I had in mind," Calle became determined never to show sketches as preliminary work. Instead, he presented a finished drawing on tracing paper done to the exact size and specifications of the final art. His approach left nothing to chance. Nevertheless, he insisted on the art director signing off on the drawings. Calle didn't like wasting his time.

These detailed drawings caught the eye of Otto Storch, art director for *McCall's* magazine, who asked permission to reproduce a tissue drawing of a large tree that Calle had brought in for approval. The artist demurred, saying it was only a sketch, not a finished piece. Storch explained that he felt it was much more than a sketch and wanted to publish it. Calle replied that he wanted to speak with Olga before making a decision.

"Are they going to pay you the same amount to use the sketch?" she asked.

"Yes," he answered.

"Then let them use it," she said, smiling.

McCall's reproduced the drawing in blue ink on gray paper. That drawing, *October Song* (p. 44), launched Calle's career in pencil illustration.

With Lavaty as his agent, Calle joined the select circle of New York's most successful illustrators. Like Frank McCarthy, Howard Terpning, Robert McCall and Tom Lovell, Calle's name became familiar to New York advertising accounts.

For a while, Calle was so much in demand that he cloned himself—twice. As did other successful illustrators, Calle operated briefly under different names. He used Paul Paulino, Paul Pierre and Paul Calle. These aliases enabled him to establish separate artistic identities: under one, he might be known for science fiction and under another he might be known for portraiture.

By the time Claudia was born in 1954, Calle's career was on firm commercial footing. The combination of a new baby and a growing business convinced the Calles that they needed more space. One memorable evening, the couple got out a map, drew a circle around New York City with a 50-mile radius and targeted Connecticut. After learning how to drive, the artist moved his family to a tree-shaded country street and the two-story spacious house they still call home.

A CONNECTICUT YANKEE

SINCE MANY OF THE ARTISTS Lavaty represented lived as he did, in the Connecticut area, the agent devised a system. He kept an old car parked in his driveway as "a drop." Finished artwork went on the front seat; assignments were picked up from the back seat. The prolific Calle, who worked out of a large room with north light in his new home, soon became a regular at the Lavaty "drop."

"It was great," Calle recalls. "The system meant artists didn't have to make trips into New York all the time. We could stay home and paint."

His children remember their father's home-based commercial years fondly. "We'd come home from school and he would be working," recalls Paul Peter, the Calles' eldest son. "If Mom was out, he'd start dinner before she came home. Was it strange for us to grow up having a father who was an artist? Not at all. It was what we knew."

Three years after Claudia was born, Paul Peter arrived. Four years later came Chris. As the activity level increased at the Calle household, the artist started searching for separate space and discovered an old barn in rural Connecticut. He leased it and set up his studio.

From 8 a.m. to 6 p.m. on weekdays, dressed in jeans and a sweatshirt, Calle worked in a romantic setting at the end of a long, twisted road. He drew and painted upstairs in a converted hayloft. Below, horses were stabled. During the daytime, the space was flooded with north light, and the view opened onto a pasture outlined with tall pine trees.

The artist with his children in his Connecticut studio, 1964; left to right: Chris, Claudia and Paul Peter.

Calle loved the barn despite the cold winters, the wind that whipped through the unheated section of the barn and the rats that nibbled at the soap in the bathroom. He was less thrilled, however, about having to put antifreeze in the toilet tank in cold weather.

"I have many memories of going to the big, red barn on Saturdays, climbing up that spiral staircase into

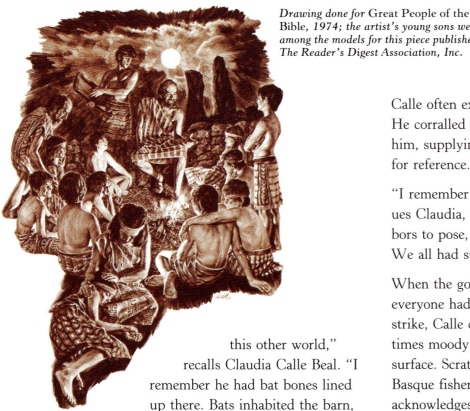

Drawing done for Great People of the Bible, *1974; the artist's young sons were among the models for this piece published by The Reader's Digest Association, Inc.*

this other world," recalls Claudia Calle Beal. "I remember he had bat bones lined up there. Bats inhabited the barn, and my father thought the shapes were interesting."

Evenings belonged to his family. In addition to Olga and the children, the Calle household included assorted creatures like Noah-the-Boa and Mac-the-Macaw. Just as his father has always been an artist, Paul Peter was a born scientist with a passion for animals. The Calles have always supported their children in any and all endeavors.

"It says a lot about my parents that after Paul Peter left for college, they still were taking care of Noah-the-Boa and Mac," laughs Claudia.

Whenever possible, Calle made his work a family affair. "When Dad was doing his NASA assignments, he kept a spacesuit and helmet in the hall closet," recalls Paul Peter. "We'd put on the gloves, and Chris would try on the helmet. One night when my father returned home, he found a spacesuit arm eerily waving at him from the front hall closet."

Calle often extended "family" to include friends. He corralled neighborhood children to pose for him, supplying the costumes and taking photographs for reference.

"I remember when he did the medical series," continues Claudia, "and my father got many of our neighbors to pose, including two physician friends of ours. We all had such a good time."

When the good times rolled at the Calle house, everyone had fun, but even today, when black moods strike, Calle can be difficult. Outspoken and sometimes moody, a crust of rebellion lies just below the surface. Scratch the Connecticut Yankee and the Basque fisherman bleeds. The artist, himself, acknowledges the disparities in his nature. Some years ago, when he traveled to Spain and visited his father's village for the first time, Calle marveled at how calm and peaceful he felt in Basque country.

Calle's children had no trouble relating to their mercurial parent.

"If my father got angry, he exploded, but then it was over," says Paul Peter. "Yes, he is emotional, has strong opinions and isn't afraid to express them; but we never lived in fear of him. We understood that for him, letting loose is cathartic."

"It was almost worse when my mother was upset, because she wouldn't get angry with you," offers Chris, a successful artist like his father.

"Basically, he's a big teddy bear," Paul Peter continues. "If he sent me to bed without supper, he came into my room later with dinner. I cannot remember my mother ever telling me to be quiet because Dad was upset or working. Sure, I remember him being frustrated, but that's because he's such a perfectionist and is so driven. He is never willing to settle. He has such a drive for excellence that falling short of it is

very difficult for him. You need to know, however, that my father is as critical of himself as he is of his work. He has little tolerance for falling short of his own expectations."

Son Chris agrees that his father never settles for less than his best. "My father," says Chris, "has the luxury of success. He's in an enviable, ideal position at the top of his field, but he is always conscientious about his approach to his artwork. My father has been my greatest teacher as well as a tremendous source of inspiration for me. In any creative endeavor, you have to keep your edge; you have to strive to be better—I think this has been the most significant value that my father has instilled in me."

"Both of my parents," continues Chris, "always wanted the best for all of their children. In terms of our shared profession in art, my father has always wanted the best for me as well. He has never, however, revealed the shortcuts; he knows that the only way to learn is on my own, the hard way."

Calle's wife and children accurately reflect the artist's attitude toward himself and his work. Although he is serious about art, he never allowed it to consume him. Confident in his talent, Calle maintains an unusual natural balance. Artist, husband, father, grandfather, he plays each role to perfection with gusto.

Despite his exacting personal standards, Calle makes little issue of his profession. He jokes about artist friends who convinced their wives that they couldn't do anything which could injure their hands. "I was out building stone walls, mowing the lawn, hammering, sawing and building things for the kids and Olga," he chuckles. "The neighboring artists hated me!"

FAST ACTION AND FINE ART

THE WOODS IN RURAL CONNECTICUT provided a romantic setting for Calle's muse, but few artists work well in total isolation. For a product of the art school/studio system, interaction was and is vital to his emotional and professional well-being. Consequently, he happily accepted an invitation to join the prestigious Society of Illustrators Club in New York. The interaction with other artists was invaluable, and, as a member, he knew he'd be privy to a world of fascinating art projects.

Like most other members of the Illustrators Club, Calle heard of many opportunities informally. Seated at captains' chairs around big, wooden tables, Calle and his peers lingered over sumptuous buffet lunches discussing their favorite topic—art—and sharing news.

Robert McCall, today well known for his space art, is one member Calle especially enjoyed speaking with at the Club. As a result of their association, McCall gave Calle several key referrals, including his first for the Garrett Corporation Calendar. Later, in the 1960s, the two took several research trips together as members of the NASA art team.

Observes McCall, "Paul is a very talented man, a guy with all the qualities to succeed. He has commitment, a tremendous curiosity about all aspects of the world and the energy to pursue his goal. Olga is an important part of the team. We artists are lucky if we find that special companion. Those who have this are two strides ahead of the other group who do not enjoy that support."

Impressed with Calle's work, McCall recommended him for the Air Force Art Program thus widening the young artist's professional circles. In the late 1950s, the Air Force began a historical program to document its global activity. About a dozen artists were invited each year to visit bases around the world, fly pseudo bombing missions, visit radar sites, view pararescue missions and record their experiences. In return, they donated their drawings and paintings to The U. S. Air Force Historical Art Collection.

"One of the most fascinating assignments was to document the activities of the crew aboard Air Force One during President Johnson's administration. Since the President was not aboard the flight, I conceived the idea of doing a series of drawings from the President's perspective—I sat in the President's seat, and all the drawings were done as seen through the eyes of the President. It was fun being President Calle for a day!"

Calle's first assignment was a five-week whirlwind trip with stops at bases in Germany, Spain and Italy. Never one to pass up a chance to do more than is expected, he incorporated Florence, Venice and Paris into his itinerary as well. Over the years, he accepted several Air Force assignments, almost always having to regretfully leave Olga at home to care for the children.

In years to come, Calle was able to add pleasure to business. Both he and Olga were invited to attend an international air mail stamp exhibition in London,

Pencil drawing of Lyndon B. Johnson with the Air Force One Seal, 1967; this drawing is one of many the artist completed for the Air Force Art Program.

where his *First Man on the Moon* stamp (p. 29) was the premier exhibition. After London, the Calles went on to Rome and then on to Greece and the Greek islands. There, Calle was inspired by the gleaming whitewashed buildings and azure blue of the Aegean Sea. He later completed a large painting, *Old Woman of Thira* (p. 45), which hangs in the Calles' dining room. With its brilliant hues, dramatic, white geometric shapes and spare composition, the painting of a Greek church represents an unusual departure for the artist. It remains a family favorite, and Calle speaks of doing a series on the Greek islands one day.

In 1962, his professional reputation and Air Force connections brought him to the attention of NASA. Calle was invited to become one of the seven original members of the NASA art team to document the Mercury, Gemini and Apollo space missions through the eyes of the artists. Ultimately, the program was known as "Eyewitness to Space."

Space presented Calle with a rich melange of sights, sounds and textures. He plunged in with exuberance. On one occasion, his humor got him into trouble. At a launch, wearing his trademark red bandanna, he wandered into unauthorized territory. A guard accosted him and demanded identification.

"I am a spy from a very poor country," Calle told him quickly. "The country is so poor it can't afford a camera, so they sent an artist with a pencil." The guard didn't laugh. He hauled Calle into custody, and it was a while before he was vouched for by NASA officials and let go.

As was the case with his commercial clients, Calle shared his adventures with the family whenever possible. Paul Peter remembers a trip to Cape Canaveral to witness a night launch. Chris recalls being

awakened to see Neil Armstrong set foot on the moon. All the Calles were thrilled when their father was chosen as the artist to be with Neil Armstrong, Michael Collins and Buzz Aldrin the morning the astronauts suited up to blast off for the moon. They were even more proud to know that Armstrong carried the engraving of their father's postage stamp, *First Man on the Moon*, to the lunar surface.

Calle credits his NASA years as the period when his pencil drawing technique came together. Sketching quickly and spontaneously, he polished his distinctive style. With only an HB lead pencil and infinite degrees of pressure on that small point, he packed tension, fear, excitement and vitality into whatever he drew. His lines became avenues pulling the viewer into the scene.

"In the early days, I tried to draw like Degas, to emulate the design qualities of Lynd Ward, the power of Robert Riggs and to paint like Bonnard, Vuillard, Shahn and Benton," says Calle.

He experimented freely with colors and more abstract shapes. Calle appreciates abstract art and notes that the best realists are abstractionists. "I mimicked many artists to find my own style," he says. "It all came together with the Gemini space drawings."

Gemini catapulted Calle into a rarefied atmosphere of fast action and fine art. To capture historic moments, he relied more on the functional use of the direction of line, developing definite and ever more intricate patterns. In one drawing, immortalizing the first step on the moon, he slashed heavy dark vertical lines on the paper to draw the eye downward to the foot. In another, the pencil strokes follow the direction of the body as it moves forward while the head is expressed almost abstractly. Rather than describe it in detail, Calle used the paper to suggest volume, a technique borrowed from wood engraving. As he explains,

"While sketching, I am aware and conscious of the positive nature of paper left untouched. The abstract shape of areas left out is as important as those covered. Negative space is very positive."

Calle's innate ability to grasp a complex situation and interpret it dramatically, coupled with his wide-ranging artistic talent, assured him of a continuing front row seat to aerospace history. If space, however, was the final frontier, the American West was still the original challenge. In conjunction with the Air Force project, the National Park Service began its own program to capture the essence of these special American sanctuaries. The "Artists in the Parks" program teamed the nation's top artists with the country's premier scenery, so the National Park Service could own a visual record of its properties. Artists were invited to visit various sites and paint their emotional and visual response. For many East Coast painters, this project promised magnificent settings they may have only read about or seen in a Western film.

In 1967, Calle was asked to chair the Artists in the Parks committee, a position he was delighted to accept. Many of the top artists were his friends and acquaintances, which made the job particularly satisfying for Calle. Among those he sent on the road were New York illustrators Kenneth Riley and Clark Hulings, both of whom returned East enamored with the Western scene. Both moved West when their fine art careers were launched.

Calle viewed these assignments as an opportunity for him and his family to travel the great expanse of our country, to explore it in a personal way. All the Calles were inspired by its visual treats. Calle never, however, suspected that these assignments would change the course of his professional life.

RENDEZVOUS WITH THE WEST

M Y MOST ENDURING and strongest visual image of my father is being on one of the National Park trips," begins Claudia. "I was 11 years old, and we were driving down a road in Arizona. It was late afternoon, and we were surrounded by a wonderful golden light. To the left, reddish mesas rose abruptly. To the right, the desert went on forever. Suddenly, my father braked, stopped the car, grabbed his camera and began running up the road. I got out and ran after him to see why he was running. And then I understood. He was chasing a cloud to get a picture of it."

Over the next few years Calle chased clouds from Arizona to Mesa Verde, and from New Mexico to the giant redwoods. The more he traveled, the more enthralled he was by what he saw. He reveled in the Western landscape and was awed by the spirit he discovered. Here was a land that brought history alive and a land large enough to contain his boundless enthusiasm.

Each trip West confirmed his excitement. Each journey provided him with new stories to tell, more images to fire his imagination. Each visit reawakened his early admiration for artists like Albert Bierstadt, Thomas Moran, George Catlin and Frederic Remington. With every experience, he wanted to know more. In time, he began reading voraciously about the West and found himself fascinated by the world of trappers and mountain men.

Calle pushed himself relentlessly on the park trips, photographing from every angle, sketching constantly.

He noticed, questioned and memorized. He willed himself to etch each image into his psyche so he could draw on each for years to come.

He and Olga chose Mesa Verde as the first assignment because they wanted to experience the land of the Navajo. Ultimately, they visited numerous parks, including Canyon de Chelly, the Grand Canyon, Yosemite and Muir Woods. The children looked forward to the trips and became accustomed to the frequent stops their father made to draw and photograph trees, rocks, canyons, clouds and shadows.

On one assignment, Calle heard that a sacred rain dance would be held on the Hopi mesa. The family headed for Shongopavi. When the highway ended, they followed a trail and drove on in brilliant sunlight.

"The memories of that day bring back to me that cloudless, crystal clear, sunny morning when my family and I were invited to witness the sacred rain dance of the Hopi people in the village of Shongopavi on the second mesa. Upon our arrival, we met an old woman who invited us to view the ceremony from the roof of her home facing the central square. We climbed the wooden ladder and sat on a bench she had arranged from old boards.

"At the appointed time, emerging from the *kiva*, an underground chamber, came the celebrants, two by two. One dancer came out with a rattlesnake clenched in his teeth, while his partner fluttered an eagle feather that seemed to mesmerize the rattler. Their bodies were covered with corn flour. There must have been a hundred celebrants, chanting and

Calle photographing in the field, 1981; these photos are important supplements to his field sketches.

dancing around and around the pueblo square scattering corn flour on the parched earth. After a good period of time, upon a given signal, they broke the circle and raced in all directions—north, south, east and west to release the rattlesnakes they had captured some weeks before. As we watched, hypnotized by

27

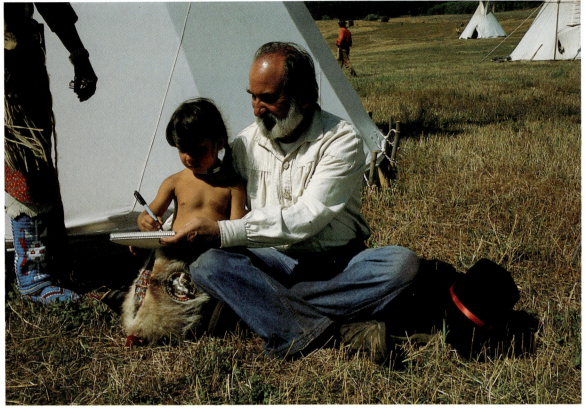

Calle with a young admirer in Montana, 1981; together they drew a horse, and the artist gave the drawing to the boy.

honoring him, I was very pleased. The Postal Service wanted a simple design that featured a strong portrait. I proceeded to execute a variety of portraits in pencil based upon photographs acquired from various sources. Mr. Frost's publisher, Holt, Rinehart and Winston, was most helpful in providing me with a variety of photographs. After completing the designs, primarily portrait studies, I thought it important that there should be some alternate selections. I conceived a series of designs that I felt gave an added dimension to the man. The designs encompassed a portrait intertwined with the sky, trees and rocks the author loved and so often wrote about. The original thoughts of the Postal Service prevailed, and we did end up with the portrait design. I did have, however, the personal satisfaction of exploring all the possibilities that I felt were significant.

"The Frederic Remington stamp was also of personal significance to me. Here was an Eastern artist whose love of the West compelled him to paint the scene. Like me, he made periodic research trips to the West and then returned to the quiet of his Eastern studio to digest what he had seen and produce his wonderful works of art. Remington died in his home in Ridgefield, Connecticut, on December 26, 1909. His home and studio are a short 15-minute drive from my own studio in Connecticut."

If the historian in Calle was exhilarated to be part of history, the father was even prouder when his son, Chris, was commissioned to create his first stamp. Calle's pride increased exponentially when Chris surpassed his father, designing 30 stamps by 1992!

the scene, it started to rain, and then it really rained! All around us, as far as the eye could see, the sun was shining, but above the village of Shongopavi was a rain cloud.

"And it continued to rain. I looked at the old woman with questions in my eyes, and she just smiled as she gathered our children around her and covered them with her blanket to keep them dry. A mystical experience; I truly believe so."

Later, when he began painting the West, Calle remembered that mystical moment and infused his paintings with spiritual energy.

By 1969, the successful commercial artist had won numerous honors for his work and had been

commissioned to design stamps for the U.S. Postal Service (right).

"Designing stamps is truly a unique experience! The subject matter is chosen for its national significance, usually of historic importance, and the conception of the design must be thought of in terms of art in miniature form. Rather than 'thinking big,' the designer must think small."

During the next 20 years, he designed 20 stamps. Calle's designs honoring Frederic Remington and Robert Frost are among his personal favorites.

"Robert Frost was a New Englander who loved the land and sky, the rocks and trees, as I do. I always feel a kinship with him when I read his poems. When I received the assignment to design the stamp

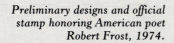

Stamps designed by Calle for the U.S. Postal Service (left to right): Dr. George Papanicolaou, 1978; Frederic Remington, 1981; First Man on the Moon, 1969; Gen. Douglas MacArthur, 1971; Pearl Buck, 1980; American Folk Art issue featuring carousel animals, 1988; accomplishments in space twin stamp, 1967; Vietnam Veterans Memorial, 1984; Clara Maass, 1976; Helen Keller and Anne Sullivan, 1981; Retarded Children Can Be Helped, 1974; Volunteer, Lend a Hand, 1983; Canoe 1800s, 1991; Blanche Stuart Scott, 1980; Aging Together, 1982; International Year of the Child, 1979.

Preliminary designs and official stamp honoring American poet Robert Frost, 1974.

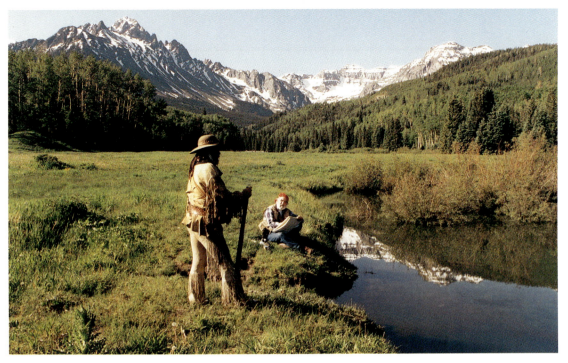

By the beginning of the new decade, the Westward push became inevitable. The move began innocently, in 1973, when his illustration career was at its zenith. Calle was completing assignments for NBC and other prestigious clients, as well as competing for and winning *TIME* magazine covers. As a boy, he had dreamed of becoming a top New York illustrator, and now he was enjoying his success. Now he stood poised on the threshold of two frontiers—space and the American West.

A single telephone call changed his life. Frank McCarthy, a well-known artist who lived in the area, called to ask if Calle would speak with McCarthy's son, Kevin, about pencil drawing. Although he did not publish his definitive text, *The Pencil,* until 1974, Calle was well known both for his technique and his distinct style. He happily obliged.

The two artists only knew each other's work, but that call spawned a long-lived friendship. When Calle showed McCarthy the large drawings he was doing for the National Parks program, McCarthy was impressed. Soon after, Calle received another call, this time from Don McCulley, an art gallery owner in Dallas, Texas, who was McCarthy's dealer.

"Frank says we should get you before somebody else does," McCulley began.

McCulley explained that he would like to meet Calle, see his work and invite him to participate in the gallery's next group show. At the McCulley exhibition a few months later, Calle's work sold out in the first 30 minutes of the show. The unprecedented success of this show prompted Calle to re-examine the course of his career. He turned to Olga for advice.

"You have always wanted to draw and paint on your own," Olga said. "Why don't you take a year off to do that?"

Calle suspected his practical bride had lost her senses. How could he consider such a thing with one child in college, another in high school and a third growing up fast? Back in Connecticut, they continued the discussion, talking for hours at their round oak kitchen table about whether he should leave commercial art to pursue his personal dream.

Calmly, Olga reassured him that the family would not suffer. "We have enough," she said simply, convinced that the time was right for him to make his move.

Free of his commercial responsibilities, Calle headed for Santa Fe to research Native American culture, the Southwest and the New Mexico art scene. He explored locations and galleries, filling his heart and head with ideas and images. Like Frederic Remington, who also went West and painted in the East, Calle brought artifacts home. He even built a kiva in the backyard.

That first trip West established a pattern which Calle follows even today. He still travels to research in the West, Northwest or Canada, returning home with sketches and photographs. As her family responsibilities eased, Olga began accompanying her husband on these journeys, working as another pair of eyes and ears to record concepts and ideas which would eventually evolve into paintings and drawings.

The West inspired Calle to begin a series of work celebrating the Navajo and Hopi. With *The Grandmother* (p. 93), *Generations in the Valley* (pp. 88-89), *Children of Walpi* (pp. 90-91), *Navajo Madonna* (p. 8) and others, he expressed his heartfelt admiration for these cultures. His palette was rich with earth tones, sun-drenched oranges, bleached greens and deep browns.

During this trial year as a fine artist, Calle was afraid to refuse commercial work entirely since he didn't know how his work in the Western genre would be received. He told clients he was on assignment and could not take on new work. Drawing constantly, he sent each new pencil piece to McCulley's gallery. Often McCulley would call requesting more work.

Calle remembers one particular exchange which occurred right after he had sent the gallery a new piece. The artist explained, "Gee, Don, I sent a drawing yesterday. You should have it any minute."

"I already sold it," came the reply. "When can I expect more?"

Right from the start, Calle found himself in the enviable position of selling everything he drew and painted. During that experimental year, not only did he draw and paint, he studied the West and its history. He soon discovered trapper journals and historical accounts which fascinated him. He was especially taken with tales of the Hudson's Bay Company and the world of mountain men and fur traders. Renegades appealed to his rebellious spirit. The untamed landscape of cruel winters and life-giving springs, inhabited only by those willing to risk everything, excited him as no other place and time.

Near the end of that year, *TIME* magazine called with another cover assignment. Calle turned them down. It was the last commercial assignment for which he was ever called. No matter. He had thrown his hat into the Western ring. Olga's sense of timing had been impeccable. During the 1970s Western art came into its own.

Calle sketching on a research trip to an encampment of mountain men and Indians along Montana's Madison River, 1981.

THE ROAD LESS TRAVELED

CALLE'S ARTISTIC JOURNEY has been a constant voyage, moving from outer space to the Western experience. With the fur trade, he found a less traveled road, which, for him, made all the difference. Here was the subject with which he could synthesize his painting and pencil techniques and his artistic influences—the subtle beauty of Degas, the emotional flow of Ben Shahn, the strong design influence of Lynd Ward and the striking nationalism of Thomas Hart Benton. In the process, it became pure Paul Calle.

Once he discovered this era of American history, he never looked back. He is mesmerized by this historical period. It only covered a period of 35 years in the early 1800s, but the fur trade has captivated Calle for more than 20 years.

For Calle, a man drawn to heroes, the trapper is a subject made in artistic heaven. Calle even looks the part. More than the clothes and accoutrements, Calle was enthralled by the life these men dared to lead. Calle was not only enthralled with them, but in a strange way, he sensed a kinship with them. His competitive soul was awed by their brash spirit. Young, bold and entrepreneurial, trappers and mountain men risked everything to win, and the stakes were high. Most were dead by the time they were 35.

As he devoured more facts about their lives and lifestyles, Calle discovered that despite their wild reputations, these men were not illiterate. He says, "Trappers carried the Bible and Shakespeare with them and read aloud around the campfire—the journals referred to it as the 'Rocky Mountain College.'" The more he studied, the more determined he

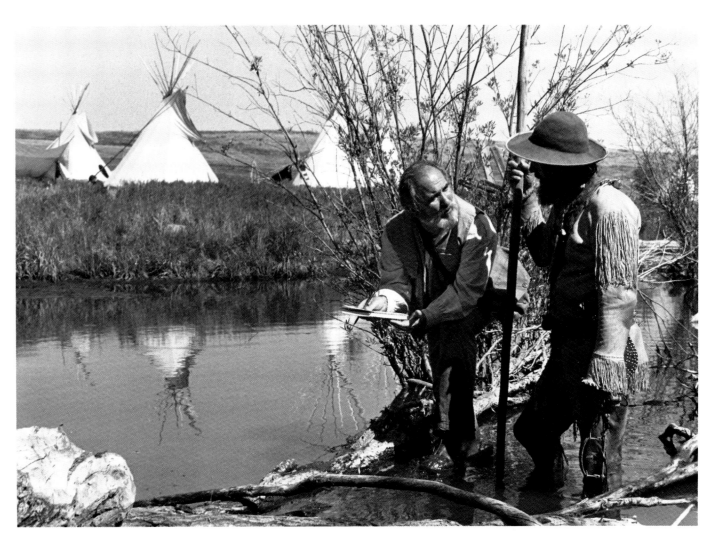

In 1981, while at the Northwest Rendezvous in Montana, Calle met Gruff, who provided the artist with source material for many subsequent paintings.

became to portray them as they really were: rugged, intelligent individualists whose lives were difficult, but whose dreams were grand.

In making this connection, Calle freed himself to indulge in conjecture. Rather than paint scenes that actually took place (the basis for historical paintings), Calle elected to portray "what might have been." Like the fur trade, his own odyssey has been one filled with adventure. At least once a year, he lives the life he paints. He joins mountain men and Western enthusiasts at *rendezvous* held in the Western states and Canada. Dressed in his own buckskins and red bandanna, Calle plays games of skill of the period, trades for artifacts and sits around the campfire, discussing what life was like in the newly opened West. For these weeks, he steps back into the time which so captivates his imagination.

No doubt Calle's journey will always be unique. Realism is critical to him. It is imperative that he walk the trails and ford the streams where trappers worked and mountain men made camp.

"When I am out there in the meadows and woods, looking at streams or beaver dams, watching the beavers work their way around to their lodges, or seeing buffalo and elk and eagles, my mind's eye sees those mountain men and trappers. For those moments, I am with them."

Nor will he take shortcuts. Years ago, when he didn't know where to buy furs for props, he haunted the highways near his studio for roadkill which he carried home and had skinned. Eventually, he discovered where to buy pelts, which made life infinitely easier.

Calle's dedication is unusual, but he cautions that his choice of subject matter is not unique. Other artists, such as John Clymer, have also mined this territory. Calle notes that he especially admires the spirit in the paintings of the late John Clymer.

Calle's own vision is especially spellbinding. His highly realistic paintings, adorned with frames of heroic proportions, deliver a story line and message which speak directly to the heart.

And what of Calle's heart? Veracity of purpose and of person is crucial to his artistic genius. Possessing the soul of a free trapper, it is not surprising that he prefers to blaze an independent trail. An outspoken and opinionated person, Calle has never sought glory by association. Although he is a convivial personality, he attends just one or two shows a year to maximize his professional output. Even his stationery proclaims his individuality. It bears his thumbprint.

As disciplined as he is determined, the artist works every day but Sunday in a contemporary setting that overlooks a stand of Connecticut woods. Calle's routine and method seldom vary. "I am a spontaneous person, but I am very disciplined in my work," he says of his work habits.

If Calle's environment is outwardly suburban, inside it's magic. Here he is surrounded by assorted skulls, dozens of "possible bags" (small pouches containing all necessities for any situation that could possibly arise), trapper hats and rifles that range from authentic antiques to museum reproductions. Everywhere are shields, pistols, powder horns, beaver and bear traps, knives and even a model of a birch bark canoe. His vast collection is hand-culled by constant searching and inveterate trading. He and Olga haunt antique shops regularly. Each piece they find adds to Calle's knowledge of the period he makes his own and ensures that he can create a moment in history without leaving his Connecticut studio.

It is revealing that this volatile artist never dwells on problems when discussing his career. Asked to

Calle in his studio with a pair of Ojibwa/Cree style snowshoes from his collection of artifacts, 1988.

comment, he explains that he left art school with no expectations and has been extremely fortunate.

"It is important to be prepared to seize opportunities," he stresses. "Yes, I've been lucky in my career, but I've also been prepared to make the most of my opportunities."

Most of all, he feels he was lucky to find Olga, good friends and mentors. "No one succeeds alone," Calle emphasizes.

Artist and friend, Ray Swanson, suggested to the invitation committee that Calle be invited to exhibit in the Western Heritage Show and Sale, a cattle, horse and art extravaganza held in Houston, Texas. The Connecticut artist happily accepted, and his work sold out.

The Western Heritage Sale was Calle's first big break in price and reputation. During one memorable evening, his painting, *The Storyteller of the Mountains* (pp. 72-73), was being auctioned at the black tie dinner at the Shamrock Hotel. Suddenly ex-Governor John Connally, an organizer of the event, stopped the bidding abruptly and pointed to the painting. "Now some of you think the old man with the red bandanna is Willie Nelson," drawled the charismatic Texan at the glittery crowd. "You're wrong. Paul Calle is so cheap he used himself for a model." Winking at the artist, Connally restarted the bidding and the price zoomed.

Another break came in 1979 when Calle was asked to become a founding member of the Northwest Rendezvous Group (NWR), an association of artists who celebrate the Western experience. For their show he completed a black-and-white drawing, *The Winter Hunter* (p. 102). As he drew, Calle saw color emerging rather than value range, and he knew instinctively he would revisit this subject as a painting. Two years later, he completed it, with the hunter wearing a red coat (p. 103) instead of the gray value in the original drawing.

The NWR show was Calle's introduction to his future art publisher, Mill Pond Press, and the world of signed and numbered limited edition art prints.

The relationship started casually. "We agreed we would give an award to one work of art we selected as outstanding," says Robert Lewin, co-founder of Mill Pond Press. "*The Winter Hunter* was selected. It was a marvelous pencil drawing."

In March, 1980, Lewin carried the newly published print, *The Winter Hunter*, to a trade show in San Francisco. Uncertain where to display the black-and-white print in a booth filled with color, he hung it directly in the center. He needn't have worried. "Everyone went right to it," Lewin recalls with a broad smile. "That print edition sold out immediately."

In the next dozen years, Mill Pond Press published many Calle limited edition prints from his original paintings and pencil drawings. The strong story line and intricate detail of Calle's original artwork have made elegant art prints, and his powerful black-and-white drawings easily maintain their integrity in reproduction. Within a few short years, Calle's limited editions were in high demand throughout North America.

What is his appeal? Lewin answers immediately. "Calle's rich paintings translate magnificently into captivating prints. His work communicates. It touches people's emotions in some special way. It has extraordinary validity. Then, too," he notes, "Calle is a consummate professional. His memory for color is exceptional. He knows what he has painted and how, and he remembers the intensity of each tone."

Limited editions greatly expanded Calle's audience. Since he only completes two or three major works and several pencil drawings a year, all which go immediately to private collectors, art prints allow admirers from North America to Europe into the

Calle collector circle—including the artist himself: "Prints let *me* collect Paul Calle."

Frank McCarthy believes Calle's spirit is what viewers notice most about his artwork, whether an original or a limited edition print. "His enthusiasm is a very strong force behind his painting," McCarthy observes. "He has a lot of staying power."

Calle's force is not only luminous, it endures. He marshals masses of fervor to prepare the detailed, full-size pencil sketches he makes for every painting. Then he sustains that level of intensity for the months it takes to complete a finished work.

"It's an interesting combination, because his volatility and moodiness do not jive with the painstaking way my father works," says Claudia. "I remember asking him once what he was painting day after day, and he said 'rocks.'"

Scenes from the artist's studio, clockwise: Calle works late into the night, adding finishing touches to his painting A Winter Surprise; some of the artist's many bristle and sable brushes, as well as a bowl containing several thousand pencil stubs—a testimonial to his love of drawing; in lieu of a traditional palette, the artist uses several trays to mix his colors in varying value ranges; artifacts collected over the years include an authentic Indian war shield and knives; some of the other artifacts familiar to many of Calle's collectors—hats, rifles, bags and capotes.

WORK IN PROGRESS

Rocks...trees...snow—no matter—there are days when Calle prefers to avoid the moment of truth. In his studio, a large, blank sheet of paper is fixed to his drawing table. The table, which swivels 360 degrees so he can draw at any angle, stands upright. White butcher trays are dotted with color, holding the values he has mixed for a painting. Within easy reach, dozens of boxes of hand-sharpened HB pencils are shaved to perfection. It took him an hour to do that job. A fishbowl filled with more than 4,000 stubs attests that Calle has put pencil to paper many times before.

Close by, closets are filled with red and yellowed capotes, hand-beaded moccasins, gloves and colorful belts. Buckskin clothing, smoked to perfection by endless campfire conversations, hangs next to suitably stained voyageur attire. In the corner, stuffed Canada geese hang ready to pose.

Everything is in order, except his psyche.

Instead of drawing, he brews his second pot of tea. He sharpens dozens more pencils, paces around his studio, moves a knife sheath next to a book, waters the plants and cleans the fireplace—anything not to begin.

"Nothing is as frightening or intimidating as standing before a blank sheet of paper," the artist admits.

Intuitively, he knows when the time has come. From that moment on, he is fully absorbed. Secure that he has completed his research, absorbed all the details and assembled the materials, whether they are sketches, photographs or artifacts, he plunges into the task at hand and never looks back.

The artist working on the oil painting
Just Over the Ridge, *1980.*

Calle works on just one painting or drawing at a time. "When I start, I put on the blinders," he says of his routine. In between major pieces, he sketches ideas for new paintings. He lets his ideas germinate, sometimes for years. After having developed the initial concept, it took five years before he started to paint *In the Land of the Giants* (p. 10).

To arrive at his composition, Calle dips into his files and builds an intimate collage that the viewer never sees. To create a tree, for instance, he pulls a knob from one, branches from others, and a gnarled root from still another until he has the tree he envisions. "It's why I say only God and Paul Calle can create a tree," he laughs.

His figures are also composites drawn from models, met at rendezvous, or friends. "What do I look for in a model?" He barely pauses. "Someone with an interesting face."

When he is ready to compose, Calle does dozens of sketches on tracing paper, often cutting them up and repositioning them until he builds the image he seeks. In two-and-a-half hours, he often dulls four hundred pencils.

Each painting is a new beginning. If there is a running continuum, it is unintentional. Still, a bearded man wearing a red capote in the snow, Canada geese slung over his shoulder and a tree within view are familiar Calle images.

On location, Calle may sketch quickly and spend

1

2

3

4

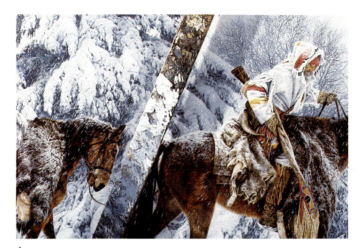

5

1. For stability, I first adhere a wooden brace to the large panel (which will become my painting surface) with wood glue and then secure it with clamps or heavy artifacts from my collection. Here, I apply the initial coat of white gesso to the panel, followed by coats of tinted gesso. Once these have dried, I begin to paint what I refer to as "flats," establishing the color of the sky, the middle ground and the snow in the foreground. Pictured behind me is the final working drawing of When Trails Grow Cold. *I try to solve all the compositional and technical problems of the painting before transferring the drawing to the prepared panel, therefore, both the drawing and the painting, when completed, measure 36" x 60".*

2. After lightly transferring the drawing, as seen within the "window" on the panel and establishing my key colors, I begin my final painting. With paper and masking tape, I create a window to isolate the area on which I wish to focus. Because the color of the capote and the rifle case are important to the final painting, it is helpful to surround myself with these artifacts from my collection.

3. When painting the variety of colors and textures of the furs carried by the trapper's horses, I refer to the specimens from my collection.

4. I keep my maulstick, on which I have placed the value range of the snow color, near the working area of the painting. Because I experience a feeling of vertigo when constantly shifting my eyes from the painting to the palette and back again, I find that it is more effective to lay out the value range on the maulstick, keeping it closer to the painting's surface, which eliminates my problem.

5. Well on the way to the completion of When Trails Grow Cold, *I knew, at this stage, I had a painting that I would be proud to sign.*

6. Finished painting of When Trails Grow Cold.

6

hours or even days photographing. He searches out scroungy horses and has found some wonderful throwbacks to the old-time breed near Easton, Connecticut. "There weren't any quarter horses then," he says of the trapper era.

Calle remembers a tough-looking old cowboy staring at his painting, *One with the Land*, (pp. 106-107) during a show. Thinking there might be a problem with it, the forthright artist introduced himself. The man peered at the thick-necked, coarse-looking creature Calle had painted, then turned to him and said, "Son, you really know your horses. That's just how they looked back then."

To support the depth of realistic detail he is known for, Calle photographs for reference. In his straightforward fashion, he makes no apology for his camera.

"For many years," says Calle, "illustrators have used photography in their work. They have been condemned for it, with justification in some cases, by the fine art community. With the discovery and realization, however, that many painters, including Thomas Eakins, Cezanne, Degas, Lautrec, Picasso and Shahn, have utilized photography in their work in some way, a re-evaluation is taking place in the attitude toward artists who utilize photographs. The utilization of the photograph is precisely the important distinction. To slavishly copy the photo, without adding to it or subtracting anything from it or interpreting it in any way, seems to me to be a waste of effort. Not to use the photo as a means to an end is really missing the value of the camera as a tool for the artist. However, the artist's eye is his greatest asset. There is a long, thoughtful process between what the artist sees and what he paints."

Back in his studio, Calle compiles his materials—photographs, sketches—and applies his talent, skill and technique to his inspirations. That process always involves the heart and the mind. Without the heart and the mind, there is nothing.

To stand in front of a Calle oil painting is both a synthesizing and moving experience. There is a sense of being catapulted back in time. The multiple layers of pure paint, meticulously applied to a panel, create a textured truth which leads the viewer into the scene. The viewer can feel the softness of the feathers on the birds, the textures of the fur and

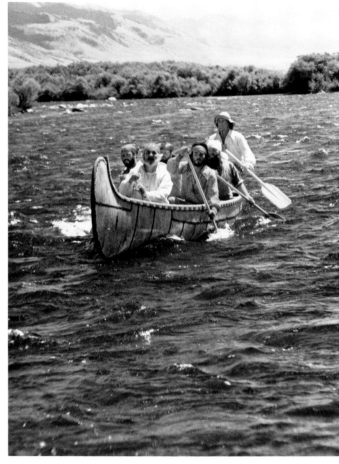

The artist canoeing on the Madison River in Montana with voyageur friends, 1982.

buckskin and can see and sense the roughness of the bark on the trees and the cold of the snow. Thousands of almost infinitesimal brush strokes cover the board, infusing it with a profusion of brilliant energy that flows directly from the artist's spirit. That force, some believe, is what sets a Calle work apart.

CHASING CLOUDS

ARTISTS ARE DRAWN to his distinctive technique, but to collectors and admirers, Calle is, most of all, a storyteller. His realistic style describes the reality of a moment, whether it's an ancient tree bowing in the wind or a mountain man trekking deep into the snow. Even more compelling than the facts he presents on paper is his ability to reveal the soul of his subjects. His deft eye, sensitive hand and exceptional use of detail uncannily capture the essence of life, imbuing his work with an emotional spirit that lures viewers into his drawings and paintings.

Don't ask Calle to elaborate about this remarkable meeting of the mind and heart. Despite his considerable intellectual gifts, Calle professes that he likes things simple. Asked to comment, for instance, on why he includes a tree in his work so often, he looks perplexed.

"I don't know," he shrugs. "Trees are a continuing theme. They are so complex and varied. Is there anything more breathtaking than a tree in the full glory of autumn color? Or the delicate pattern of leafless branches etched against a winter sky? Maybe I associate trees with mortality," he finishes. Considering his statement, he questions himself. "Or maybe renewal? I know. It's simple," he proclaims. "I love trees."

Calle sketching at The Great Rendezvous of the Voyageurs, Thunder Bay, Ontario, 1992.

Today, for Calle, change is largely a matter of nuance. Although his work continues to evolve, variations are subtle. "My directional flow is still very much as it has always been," he insists, "but I'm seeing new tonal things happening as I'm drawing and painting. I'm surprised when I see how I treat certain areas, and that is the excitement of growth as an artist."

Pressed to speculate about where these tonal changes are taking him, Calle backs off. "Who knows?" he says. "Maybe I'll start adding color to my drawings again one day. I did this in 1970 with the piece I completed on Kent State (p. 45). You see, I never sit down and say, 'Today I am going to do this or make this change.' I went through all that during my commercial art years, and it's history."

Some years ago, the artist did experiment with a new medium, lost wax. He loved the process. The dimensional quality of sculpture appealed to his sense of design and the malleable material gave him new freedom. For a man who spends hundreds of hours at the easel making thousands of tiny, meticulous lines, the spontaneous quality of wax was at once both exciting and liberating.

Two of his pieces have been issued: a buffalo skull belt buckle he wears frequently and a bronze head, *Free Trapper*. The bronze depicts a windblown mountain man wearing a raccoon-pelt headgear and, upon closer inspection, resembles the artist. To model it, Calle let his beard grow long and fashioned the trapper's features after his own. Having identified

Pushed toward introspection, Calle pleads ignorance. "I'm not that deep," he professes, shying away from heavy philosophical discussion. "I simply like to draw," he insists. Then he quotes Degas who had informed his friend, Forain, that he wanted no oration at his funeral. "However, if it were necessary, and if there had to be one, you, Forain, get up and say, 'He greatly loved to draw, so do I' and then go home."

Like Degas, Calle greatly loves to draw. It is his strength and the focus which directs his life. He channels all his energy and introspection through his pencil. Not surprisingly, his work reveals much about the inner man. His method of completing a detailed, full-sized sketch for each painting, for instance,

accurately reflects his need for control. Calle is most comfortable when he is prepared and in charge of situations.

A complex personality, the artist can be loving and argumentative, effusive and critical, intense and calm, irate and agreeable. Like his drawings, he is a powerful study in black and white. Then again, as Ray Swanson suggests, "Most of us do show ourselves in our work in one way or another."

His strong sense of self also colors his work. Unlike other artists who experiment with styles and techniques, Calle is secure in his professional approach. "By the time I evolved into the Western experience, I knew my style," he declares. "I didn't have to search for one."

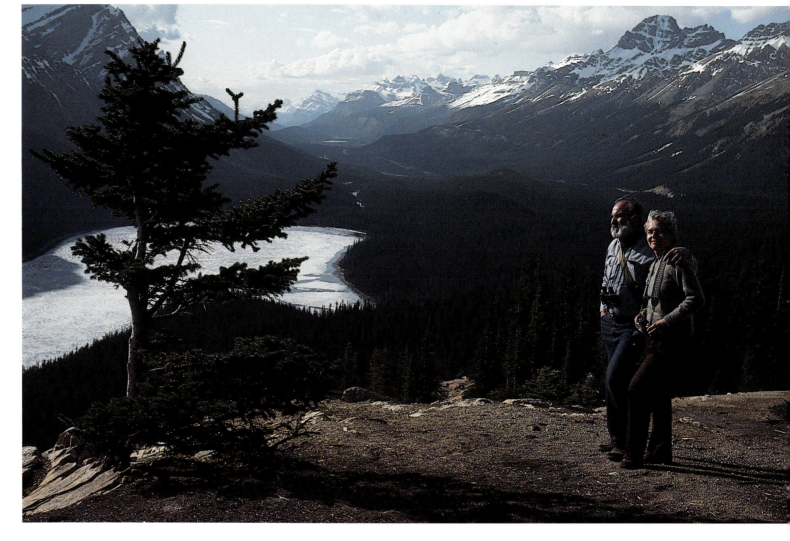

Paul and Olga Calle in the Canadian Rockies,
"...the best is yet to be..."

with the free trapper for years, this piece enabled him to seize the subject and make its spirit his own. He intends one day to continue with his sculpting.

Although Calle insists he keeps an open mind whether discussing art or myriad other topics, he is known for his strong, outspoken voice. He bases his opinions on instinct, research and knowledge and is rarely reticent about sharing them. Calle is careful, and when he believes he is right, he feels obliged to articulate his feelings even though they may be contrary to the opinions of others.

Although he had no dreams beyond commercial art, he has become one of the great chroniclers of the Western experience. For the past two decades he has been in the enviable position of painting subjects he enjoys for a ready coterie of collectors. His work has been exhibited in major museums and hangs in prestigious collections throughout the country.

The powerful works Calle has produced during the past 20 years are a prelude to more dynamic compositions yet to come. Blessed with an insatiable intellectual curiosity, prodigious energy and inherent drive to draw, Calle is intent on pursuing his mission which is to draw and paint "not what was, but what might have been."

His philosophy would please the French moralist, Joubert, who observed centuries ago, "...Illusion on a ground of truth, that is the secret of the fine arts." By this and every other artistic measure, Calle is a masterful illusionist.

And what of Calle's own artistic future? He declines to speculate on subject or style, insisting he has not yet hit his stride in terms of topic or technique.

"My consuming love and enthusiasm for the historic West remains undiminished, and who knows what is around the next bend? Perhaps Robert Frost said it most eloquently in his poem, 'The Road Not Taken:'

...I shall be telling this with a sigh
Somewhere ages and ages hence:
Two roads diverged in a wood, and I—
I took the one less traveled by,
And that has made all the difference.

"For me," says Calle, "the journey has just begun."

41

The Evolution of Style

Looking back on one's artistic career, it is always interesting to trace the development and evolution of artistic style. Consciously or unconsciously, a person is influenced by what came before, at times subtly and at other times by deliberate pursuits. In the end, life is the subject material of an artist, and all the experiences encountered along the way become part of one's art. Creating a style is something that evolves as the artist matures, having its roots in the life experiences of the artist.

Boy with Ducks, 1944 (top left)

This scratchboard drawing, completed at the end of my first year at Pratt Institute, was an early manifestation of my interest in black-and-white drawings.

Homage to Lynd Ward, 1945 (left)

Looking back over the years, my strong, youthful admiration of Lynd Ward remains to the present time. I still see evidence of his influence in my work today—the strong directional flow of line leading you in and out of a drawing, the stylized concepts of trees and flowers, the wonderful sense of positive force and negative space. My 1945 scratchboard, *Homage to Lynd Ward*, is my tribute and thanks to this great artist.

Homage to Ben Shahn, 1949 (above)

1949 brought me to Ben Shahn. I was strongly motivated by much of the socially active political messages in his work and, more importantly, by his wonderful fluid style which seemed to combine the flow and color of his own work with the strong design qualities of Lynd Ward's art. I pursued variations of this combination for several years.

Boris Godunov, 1954 (left)

I experimented even further, evolving into a more stylized technique. At the time, this concept was quite effective when used in spot illustrations and album covers.

The Widow, 1958 (bottom)

In the 1950s, the prevalent abstract movement exerted some influence on my paintings, although my commercial assignments remained quite different. To the design qualities of my 1954 *Boris Godunov* piece, I now added a very heavy impasto to my oil painting. Building upon layer after layer of underpainting, the painting had almost a two-dimensional effect.

Paul Peter, 1964 (right)

The 1960s brought a return to the beauty and clarity typified by Degas, an artist whose drawings are without peer. To the drawing I added some water-color washes to enhance the pencil. To me, the drawing has added meaning for it is of my son, Paul Peter. The bird is symbolic of his lifelong love of wildlife. Today he is a Doctor of Veterinary Medicine at the New York Zoological Society, fulfilling his lifelong dream.

October Song, 1967 (left)

This drawing of the old gnarled tree is of great significance to me. The pencil was planned as a preliminary sketch for a painting commissioned by Otto Storch of *McCall's* magazine. Upon seeing it, Otto felt it was much more than a sketch and that it should be reproduced as it was. His views prevailed, and it became the first of my drawings reproduced in a magazine.

Christopher, 1968 (bottom)

Christopher was a return to my Degas experimentation. Little did I realize at the time that this drawing of my son with my hand on his shoulder would prove prophetic! Chris embarked upon an art career, and we share many thoughts and ideas...and many memories.

Lt. MacReady, 1969 (below)

I continued to experiment with the combination of pencil and watercolor. This drawing/painting is in The U.S. Air Force Historical Art Collection.

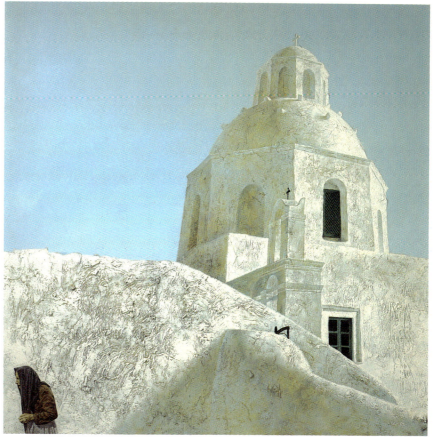

Kent State, 1970 (above)

We were all touched by the Kent State tragedy in 1970. This drawing was my response to that event. The addition of the red blood was more than a strong design element; to me, it was symbolic of that sad occurrence.

Dr. Halsted, 1972 (top, right)

This drawing of Dr. Halsted was one of a series depicting great moments in the history of surgery commissioned by Schering Corporation. It was one of the most enjoyable assignments I've ever had. It was a joy working with the art director, the writer and the client. In many ways, the "Classics in Surgery" series solidified my standing as an artist who greatly loved to draw. This final evolution of my pencil technique is the same as I use to this day.

Old Woman of Thira, 1972 (right)

This painting of a church and old woman was the result of a trip to the Greek island of Thira. The paint, the media, the panel and the technique are the same that I employ today. The 45-year evolution of my work seems to have germinated and borne fruit in the 1970s, for the painting and drawing technique are much the same today.

JOURNEY INTO
SPACE

Essay by
James Dean

"That's one small step for man,
one giant leap for mankind."

IN THE BEGINNING
—MERCURY

Dawn broke over Cape Canaveral's scrubby, subtropical landscape, and another scorching Florida day unveiled itself. The Mercury Atlas rocket glistened in a ring of searchlights as it was primed for flight. We were at Roadblock 17, less than a mile from the launch pad, waiting for the last Mercury astronaut to blast into space. It was May 15, 1963.

After a 24-hour delay caused by a balky gantry that refused to roll away from the powerful—and sometimes temperamental—Atlas rocket, Astronaut Gordon Cooper was ready for a ride that would take him around the earth 22 times—a necessary prelude to achieving the national goal of landing a man on the moon and returning him safely to earth before the end of the decade.

We, too, were ready that May morning. Paul Calle and I, along with six other artists, were sitting on the roadside at this closest point to Launch Complex 14. For five days, we had wandered freely about this new spaceport, sketching, painting and photographing. I wanted the artists to see everything and to have a full appreciation of the danger and adventure facing the astronauts; after all—these men were stepping off the planet into a new and hostile environment.

I had been with the National Aeronautics and Space Administration (NASA) as their art director for a couple of years when I was asked to develop and direct a program that would, with the help of artists, document the history-making events of the space program.

There are many precedents in American history for this kind of program. Explorers in the 16th century had artists along to record their discoveries. A French artist named Le Moyne traveled with an expedition in southeastern North America in 1564, and English artist John White painted at Sir Walter Raleigh's colony at Roanoke Island in 1585. Later, artists Karl Bodmer and George Catlin and others followed expeditions throughout the West and left us a visual record of that magnificent new frontier and its native inhabitants. Artists have gone off to major wars involving this country, from the Revolutionary War to the Persian Gulf, to document history in a variety of media.

Paul Calle and the Apollo Lunar Module at the National Air and Space Museum, Washington, D.C., 1976.

Power
oil on panel
50" x 58", 1963
*(Image photographically altered
to simulate movement.)*

Unlike previous sponsors, NASA was in the unique position of being able to pinpoint, with a small margin of error, the time and place where history would be made and offer artists a ringside seat. Former NASA Administrator James E. Webb said at the beginning of the Art Program in 1963, "Important events can be interpreted by artists to give a unique insight into significant aspects of our history-making advance into space."

With the advice of the U.S. Fine Arts Commission and the help of the National Gallery of Art in the person of the late H. Lester Cooke, Curator of Painting, I set up the NASA Art Program.

In a letter to prospective artists, Dr. Cooke stated that NASA was interested in obtaining more than just a factual record of its activity:

"...It is the emotional impact, interpretation and hidden significance of these events which lie within the scope of the artists' vision. An artist may depict exactly what he thinks he sees, but the image has gone through the catalyst of his imagination and has been transformed in the process. Style in this assignment is unimportant. If you see events in nonobjective terms, represent them this way. NASA is commissioning your imagination, and we want records of fleeting impressions and poetic by-products of thought as much as precise documents of optical experience. What is important is that the artist gives us his personal and sincere interpretation...I am convinced that artists should be key witnesses to history in the making, and, that in the long run, the truth seen by an artist is more meaningful than any other type of record...I want to build up a collection of drawings and paintings which will convey to future generations some of the excitement and wonder we feel as we cross the space threshold..."

Paul Calle was one of eight artists invited to cover Cooper's Mercury flight. Those at Cape Canaveral included, in addition to Calle: Lamar Dodd, Peter Hurd, Robert McCall, John McCoy,

Robert Shore and George Weymouth and, on the recovery ship in the Pacific Ocean, Mitchell Jamieson.

Calle's acceptance of the invitation was immediate and enthusiastic. He was 35 years old at this time, the youngest invitee. I was 32, and he has often spoken of us as the "kids" in the group.

Paul Calle and I first met each other—quite casually—in the pool of the motel where our group was ensconced. Recently, Calle said, "I was thrilled to be part of the group...to finally meet Lamar Dodd and Peter Hurd, artistic pillars of my youth, was just incredible."

The sun was well above the horizon when the bulky red service gantry rolled on its tracks away from the slender, dazzlingly white Atlas rocket with the Mercury spacecraft on top. The astronaut, lying on his back inside the cramped cabin of the spacecraft, communicated with the Control Center as the countdown progressed. The rocket, loaded with fuel and steaming in the humid air, was poised to carry Gordon Cooper into earth orbit.

Paul Calle sat in the sand by the side of the road about a quarter of a mile from the launch pad, sketching quickly, waiting for the blastoff. We were lucky to be so close. The press was there from all over the world, about 800 yards behind us. In front of us, with engines running, were rescue vehicles ready to plunge into a fire or the ocean and pluck the unlucky astronaut back to safety should a catastrophe occur. Several helicopters circled overhead as the countdown reached, "3...2...1." An orange fireball, as bright as the sun, appeared at the base of the rocket. Clouds of smoke and steam started to envelop the vehicle as it began to climb, slowly at first,

Astronaut Gordon Cooper is helped into the Mercury spacecraft shortly before launch in May, 1963. This flight was the last of the Mercury program and took Cooper around the earth 22 times.

into the blue sky. There was no noise for several seconds, then the first sound washed over us like a tidal wave. The roar of the rocket engines was startling and palpable. Calle was on his feet. "My God," he shouted, "there's a man in that!"

Calle's reaction to the events of those five days at Cape Canaveral is apparent in two large oil paintings and many on-the-spot drawings. One painting called *Power* (p. 51) captured the overwhelming force required to launch a small Mercury spacecraft with a single astronaut aboard into earth orbit. Brutish though it was, it was minuscule compared to the

power used later to propel three men to the moon in Apollo 11. It was a subject Calle would return to again. He saw that the space program represented incredible technology controlling enormous power. His first painting revealed this. His later works documented the awesome power of the Saturn 5 engines as they began the process of accomplishing the greatest technological achievement in the history of exploration, the first manned landing on the moon.

Gemini V Recovery
pencil on paper, 22" x 30", 1966
Gemini astronauts Pete Conrad and Gordon Cooper are
welcomed aboard the recovery ship after their earth orbital
flight in August, 1965.

53

Calle's feelings about the conclusion of Project Mercury were expressed in a large oil painting entitled *Knight's Armor–The End of the Beginning* (p. 52). Through the compositional elements of the empty spacesuit, the helmet and the smiling face of the astronaut, Calle suggests the change that has occurred. The empty spacesuit is like a discarded chrysalis, no longer needed because metamorphosis has taken place. This masterful rendering of subject and emotion commemorates the conclusion of this country's first tentative probing of the space around our planet. The first faltering steps have been taken, and mankind has changed. Things will never be exactly the same.

When the on-the-spot drawings from this Mercury flight were shown in Washington in 1963, Frank Getlein, art critic for *The Washington Star*, wrote: "...About 60 of the sketches went on view last week at the NASA building, and they forcefully argue the case for art in government. Eight American artists were used to cover the Cooper flight... The program comes under the general heading of documentation, and there may be, somewhere in NASA, the sophisticated assumption that the artist's sensitivity can reveal things missed by the camera but vital to the men in charge of America's space program.

"For the nonspace connoisseur, there are other values, and they are largely those of any art. The excitement of this high enterprise comes through in the drawn line more than it does in photographs. The artist's own reactions guide ours, as in all art, and we feel, indeed, that we are on the spot in spirit.

"In some cases we also feel an unsuspected tie between these events of our time and the past...

"Paul Calle's views of catwalks in the upper levels of the gantries instantly remind you of Piranesi's fantastic architecture, and we reflect on how much has come from the artistic imagination into daylight reality..."

The art produced by Paul Calle and the other artists in response to the last Mercury flight made up most of the exhibition held two years later at the National Gallery of Art in Washington, D.C. The show was successful, and its run was extended. The NASA Art Program was off to a good start.

Gemini Liftoff
pencil on paper, 30" x 22", 1965

TWINS IN SPACE —GEMINI

GOING TO THE MOON, landing and coming home required years of training and experience. In 1965, the United States space program did not have much of either. With the Mercury project completed and Apollo still in the future, a new manned program called Gemini was being prepared for its first orbital mission.

The new spacecraft looked like a larger version of the bell-shaped Mercury. It was designed to support two astronauts in space for about two weeks and allow them to rendezvous and dock with another vehicle. An astronaut would be able to open a hatch, step outside into the vacuum of space, perform certain tasks, then return to the cabin. When a mission was completed, the Gemini would re-enter the earth's atmosphere and parachute into the Atlantic Ocean. The first manned mission, Gemini III, involved a three-orbit flight by astronauts Gus Grissom and John Young.

Having artists record this new step into space was a natural continuation of the program we started during Mercury. With artists assigned to work at the Cape during launch, I asked Paul Calle to go on the recovery ship and cover the splashdown. This meant being in the middle of the Atlantic Ocean aboard the aircraft carrier Intrepid several days before liftoff and waiting through the countdown, launch and orbital flight. When re-entry and the landing were successfully completed and the astronauts safely aboard, then Calle could go to work.

In March, 1965, Paul Calle went aboard the aircraft carrier Intrepid to document the recovery of Gemini astronauts after the first orbital flight in that program.

Flotation Gear
pencil on paper, 22" x 30", 1965

Calle, deciding there could never be enough time for research, began his work as soon as he walked up the gangway and stowed his gear. He asked to be led through a dry run of all recovery activities aboard ship. He was shown every examination room and piece of equipment that would be aimed or poked at the returning spacemen. Calle probably learned more than he ever needed to know about the medical "debriefing," as they called it; it all came under the heading of research and readiness. He learned how the Gemini spacecraft, plucked from the ocean and brought aboard, would be examined by engineers and prepared for return to NASA. Calle met everyone involved, from the Captain to the doctors and the Navy frogmen who would help the astronauts into their rubber life raft. He studied and analyzed the procedures so that when the time came he could move and work in familiar surroundings, anticipating each step, keeping out of the way, yet not missing anything—a thoroughly professional approach that did not go unnoticed.

Calle said of the experience: "You had to understand their needs for work and privacy. You had to be almost like a fly on the wall. The doctors had test procedures where they would go through everything using a sailor as a stand-in for an astronaut. I spent every free moment actually seeing what was going to happen—so I was already plotting in my mind where I would be sitting, where I would be sketching. By the time the actual event came along, I was ready. I had been through a rehearsal."

Drawings that began as a reaction to the recovery of Grissom and Young expanded to a series of more than 30 pencil drawings, each measuring 22" x 30", which we called the *Gemini Sketchbook*; but they were much more significant than that. Calle's technique with the simple, basic art tool—the pencil—evolved over a year's time into a masterful display of an artist's imagination and highly refined skill. He sketched astronauts, of course, but also doctors and medical technicians, the spacecraft engineers, the Marine guards and the curious sailors aboard the Intrepid. He looked at new flights, inside and outside the spacecraft, and his portraits still ring with the excitement and energy we all felt as America pushed higher and farther into space. He went beyond Gemini III and captured the excitement of the whole program.

"The Gemini work really was the beginning of a new career for me—my love of the pencil. I became

known in the commercial world for my black-and-white drawings. Many people thought of drawings as preliminary to something else. I felt they were complete unto themselves—they just happened to be black and white. And I approach them the same way I do my paintings. I execute a full-sized pencil study drawing on tracing paper as a preliminary for my finished drawing. People often wonder if I lose my enthusiasm for the piece in working this way, but I don't. This is all part of my planning process. When I begin my final drawing, everything is worked out—the composition, the placement on the paper, everything—I try to solve it all. In this way all I have to be concerned about is the directional flow of my strokes and my value range. This is the same process I employ in composing my large paintings."

Engravers love Paul Calle's drawings. His pencil lines, both robust and delicate, swirl and shape the form. They move our eye according to his plan, taking it here and there, showing us exactly what he wants us to see in the order he wants us to see it.

Soon after the first public display of the *Gemini Sketchbook*, Calle was asked by the U.S. Postal Service to design this country's first twin stamps. These stamps celebrated the nation's space accomplishments and the successful completion of the Gemini program.

"The twin stamps were my first stamp design and the first pair of stamps this country produced. I had no conception of the uniqueness of this. I believe that, today, it is probably the most valuable sheet of stamps because the Postal Service didn't print that many and it was a 'first.' I wish I'd known, because I was sticking them on envelopes and sending them on everything."

The twin stamps showed an astronaut walking in space on one stamp and the Gemini spacecraft orbiting the earth with the hatch opened on the other. The two stamps are connected graphically by an umbilical cord that provides oxygen, communication and a tether between the astronaut and his spacecraft.

A ceremony unveiling the new stamps was held at the Kennedy Space Center in Florida in September 1967. Calle recalls: "My wife, Olga, and I attended the first day of issue ceremony, and I was seated next to astronaut Mike Collins at the luncheon. During the meal, I said to Mike, 'What was it like to walk in space?' [Collins had completed an extended Extra Vehicular Activity (EVA) during his Gemini X flight, a little more than a year earlier.] He replied, 'Frankly, it was so cramped in the spacecraft, I could hardly wait to open it up and get out of that thing. But tell me, do you mix your paint on the canvas or on your palette?' It turned out that Mike was very interested in art and had done some painting. I told him, 'When you go to the moon, take me along and I'll teach you to paint.' He said, 'Deal!' Little did I realize that years later he would be assigned to the Apollo 11 crew. When I heard this, I wrote to him saying, 'a deal is a deal. You've got to take me along, and I'll teach you to paint.' He wrote back saying that he probably couldn't arrange the trip, but that maybe we could have lunch sometime. It turned out to be breakfast on launch morning when I was covering Apollo 11."

Gemini IV
pencil on paper, 30" x 22", 1965
Gemini astronauts James McDivitt and Edward White head for the launch pad on June 3, 1965. On this flight, White became the first American to "walk" in space.

Borman and Lovell
pencil on paper, 22" x 30", 1966
Astronauts Frank Borman and James Lovell after their long duration flight in December, 1965.

ON TO THE MOON
—APOLLO

AMONG THE MORE THAN ONE MILLION people gathered around Cape Kennedy, Florida, on July 16, 1969, to watch Apollo 11 blast off to the moon, was a group of artists invited by NASA to interpret this historic event. While thousands of complex cameras and optical devices were trained on the launch pad watching every moment of the countdown, these artists were ready to document the preparations for the journey using methods as old as recorded history. Through the artist's eye, hand and imagination, a unique record for the future would be made of one of the most important events of our time—the first manned landing on the moon.

While I was able to place artists in various locations at the Cape, in the Houston Control Center and on the Pacific Ocean recovery ship, I particularly wanted to have an artist present while the Apollo 11 crew prepared for their flight. This area was the most limited in terms of room and time. Only a small number of people are allowed in the quarters where the suiting up takes place, and all have a specific part in the process. Adding an artist as an observer took a lot of persuading both at NASA Headquarters and at the Manned Spacecraft Center in Houston.

My plan was finally approved, and I believe it was partly because of the record of achievement in developing the NASA Art Collection and mostly because I had selected Paul Calle for the assignment. Calle had proven himself on previous art projects with NASA, particularly the *Gemini Sketchbook*, and his coverage of Apollo 7, the first manned Apollo flight. Also, we at NASA knew that Calle had been selected by the U.S. Postal Service to design the *First Man on the Moon* commemorative stamp. He completed work on the stamp a month before the Apollo 11 launch. The Postal Service convinced both NASA and the astronauts to take along the engraving from which printing plates for the stamps were eventually made and a "moon letter" carrying an engraving proof of the stamp.

Apollo 1

A fire in the Apollo 1 spacecraft took the lives of astronauts Virgil Grissom, Edward White and Roger Chaffee. It occurred on Jan. 27, 1967, during a launch pad test at Cape Kennedy. Nearly two years passed before manned spaceflight resumed in the United States.

In a letter to me dated Feb. 4, 1967, Paul Calle said, "It's strange how personally I feel the disaster. I imagine that because I was part of the NASA Art Program and having met Grissom on the carrier, it would follow that I feel the loss in a personal way. I wish now that in the Gemini Sketchbook I had something more of Grissom as my personal memorial to him..."

At this time Calle had been developing a painting showing the Apollo 1 crew preparing for their flight. Full-sized pencil drawings had been done of the various elements. These drawings, some on tracing paper and assembled in a final composition, were sitting in his studio awaiting transfer to a gesso panel. When the accident occurred, work stopped. After months of mentally wrestling with what to do, Calle decided that his painting would stand as their flight, unfinished also. This large composite drawing is in the collection of the National Air and Space Museum.

Untitled (detail)
pencil on paper, 96" x 48", 1967

Apollo 7—Testing the Spacesuit
pencil on paper, 28½" x 38½", 1968

A technician monitors an Apollo 7 astronaut's spacesuit prior to flight.

In the early morning hours of July 16, 1969, the Apollo 11 crew prepared for their historic voyage. In order to provide as complete a record as possible, NASA asked one artist to document the predawn suiting up of astronauts Armstrong, Collins and Aldrin as they prepared for the first manned lunar landing mission. While a number of artists were covering other aspects of the flight, this assignment was entrusted to Paul Calle. He was present while the crew ate breakfast and followed them as they donned their spacesuits. Calle's on-the-spot drawings provide a graphic record of the meticulous procedures involved in preparing three human beings for space travel. They also contain a sense of the excitement present that morning as America braced itself for the climactic mission of the Apollo program and the realization of an age-old dream to visit another planetary body.

His muscles were pumped full of adrenalin, and his nervous system was in high gear, peaking each time he caught sight of the distant launch pad searchlights which crisscrossed in the black sky. The Saturn rocket topped with the Apollo spacecraft was now in the open with its gantry rolled back. It was waiting for its crew, and Calle would be seeing them soon.

He parked near the crew building, picked up his sketch materials and headed for the guarded door.

"I had credentials, and I knew there were two checkpoints I had to pass," he said. "The guard on the door had my name on his access list so I was allowed inside. When I reached the entrance to the crew quarters, there was another guard with a clipboard and another access list. I met the NASA photographer here, and we presented ourselves to the guard. Checking his list the guard found only the photographer's name! Mine wasn't on the list! I thought I'd have a heart attack right there! The photographer went on inside promising to find help for me. Soon he returned with Chief Astronaut Deke Slayton, whom I'd met on Apollo 7; Slayton straightened things out, and I was allowed inside. Slayton seemed to have the ultimate authority about what went on, and I was really glad we had become friends."

Calle said: "It was an incredibly unique experience to be with the Apollo crew that morning. I felt highly privileged to be in that room sketching, knowing that they were carrying my stamp to the moon."

Being selected for this position also had a drawback. Everyone who would come into contact with the crew had to adhere to strict medical quarantine procedures in order to eliminate the possibility of transmitting a virus or bacteria to them. Exposure to even a simple cold would cause serious problems for the astronauts during the moon flight. Calle had to undergo a physical examination, keep a record of any illness and report periodically to medical authorities. He said, "I had to keep track of every sniffle, every cough. It was an honor system, but I knew the historical significance of the mission, so I was careful, and, happily, nothing happened." Later, when he arrived at Cape Kennedy, he underwent yet another physical and was pronounced healthy enough to be with the crew.

In the predawn darkness of launch morning, Paul Calle drove himself through the winding roads of the Cape Kennedy military installation, taking the back way to the Kennedy Space Center and the Crew Quarters Building. This route, while lonely, dark and long, was the quickest. The more direct route was clogged with cars, trucks, vans and campers belonging to the million spectators gathering for the historic event. Calle was on his way to participate in this event too, and he could not get there quickly enough.

Still cautious about germs, a NASA technician gave Calle a white gown, a cap and a surgeon's face mask to wear before he was allowed into the room with the crew. Astronauts Neil Armstrong, Buzz Aldrin and Mike Collins were having breakfast when Calle walked in and began sketching. "Mike kept looking at me drawing," said Calle. "He kept eating, then he'd look up. He did this several times. Finally he asked, 'Is that you, Paul, behind that mask?' I said, 'Yes. Remember, you invited me to lunch sometime. Well, this isn't lunch, but here I am!' He stopped eating and came over to look at my sketches. I was amazed. Here he was on his way to the moon, and he stops to look at my drawings."

When the breakfast was finished, the suiting up began. Calle said, "All around me was a scene of complete calm and incredible confidence." The astronauts, each with his own crew of technicians, went through the elaborate process of suiting up. Deke Slayton moved among them, speaking quietly.

Piece by piece, the cumbersome suits were pulled on and checked. Oxygen, communication and cooling

61

*"…looking like business men with attache cases
on their way to another day at the office."*

*"…Neil Armstrong turned and, with his arm raised,
gave Calle a thumbs-up sign."*

lines were connected and checked. Gloves were pulled on, and wrist rings clicked securely. Fish bowl-like space helmets were snapped in place, sealing off the astronauts from the world. The suits were pressurized, and it was almost amusing the way they suddenly stiffened and popped out. Calle watched all this, making drawing after drawing. The astronauts picked up their portable oxygen containers, and, looking like business men with attache cases on their way to another day at the office, they stepped out of the room and walked down the corridor toward the elevator. They waved to cheering and applauding co-workers who lined the hallways watching them pass. When they arrived at the elevator, Neil Armstrong turned and, with his arm raised, gave Calle a thumbs-up sign.

A van waited outside to take the crew the short distance to the launch pad where their Saturn 5 moon rocket sat gently steaming in the hot, humid air. The last moments in the countdown ticked away. The journey to the moon was about to start.

Seeing a blastoff for the first time is quite an experience. You first see the fire under the rocket as it

moves off the ground, but it's halfway up the gantry before you hear any sound at all. All you can hear is people screaming and yelling. There is a delay of about ten seconds before you hear the thunder, and it is a palpable sound. If you watch carefully, you can see the invisible force of the blastoff: shrubbery and trees bend and move, ripples form on nearby ponds and the fabric of people's clothing is pressed against their bodies.

"When the Saturn fired," Calle recalled, "it took so long for that huge rocket to leave the ground that everybody was urging it to go—as if the cheering helped it move. And the silence—the rocket was blasting away, and you couldn't hear anything, just people screaming, 'Go! Go!' Then, slowly, it lifted off the pad on a column of fire and smoke, and then the thundering sound waves rolled over us. Now everybody was screaming, and some were crying. What a moment! People were hugging each other as Apollo 11 disappeared into the sky.

"When we heard they were safely in orbit," he continued, "Olga and I decided to return home to be with our children, to share that step on the moon with them. We sat glued to the television set. Fortunately, when Armstrong took that first step, it was perfect. Just as I envisioned it on the stamp. I knew I would paint that scene again.

"First I had the sketches to think about. What an experience! And what about the Saturn 5? Without that power they never would have gotten there. I decided, once again, to paint that enormous fireball. The memory of watching that moon rocket blast to life and roar into the sky was so sharp and clear, I had to paint it. It's called *Power to Go* (p. 65).

When that was finished, I started on a 4' x 8' painting of the first step called *The Great Moment* (pp. 46–47)."

Through the medium of television, this historic moment was broadcast live around the world. It was estimated at the time that one-sixth of the earth's population watched as Apollo 11 astronauts walked on Tranquility Base, a quarter of a million miles away. These blurry images made a lasting impression on most of us who, like Calle and his family, were "glued" to our television sets. It wasn't until the crew returned with sharp color photos taken on the moon that we got a better understanding of what it was like. There are, however, no photos of Armstrong's first step, only the ghost-like images on a television screen. Thanks to Calle, we now have a view of that historic event. In his large oil painting, *The Great Moment*, Calle has placed us on the barren, gray surface of the moon as Neil Armstrong steps away from the Lunar Module "Eagle." We see this with a clarity and understanding that only the artist's imagination and skill can provide.

When this work was shown at the National Air and Space Museum in Washington as part of a large exhibition commemorating the 20th Anniversary of Apollo 11, Hank Burchard wrote in *The Washington Post* (July 21, 1989): "...Paul Calle runs away with the show. There's nerveless boldness in his composition of 'First Step on the Moon' (*The Great Moment*, 1969) in which Neil Armstrong's exit from the lunar lander is dwarfed by the harsh bleakness of the moonscape and the vast black void of space..." Future generations will owe a debt of gratitude to Paul Calle for preserving this moment.

Calle's work with NASA continued. He covered Apollo 17, the last flight to the moon, and, in 1971, he spent a week in the control center at NASA's Jet Propulsion Laboratory in California, documenting another historic moment when the unmanned Mariner 9 became the first spacecraft to orbit Mars.

In 1974, he traveled to Moscow for NASA to sketch astronauts and cosmonauts training for the Apollo-Soyuz Mission which took place in 1975.

"Being with astronauts Tom Stafford, Vance Brand and my old friend Deke Slayton while they trained with Russian cosmonauts Alexei Leonov and Valeriy Kubasov in Star City, just outside of Moscow, was another memorable experience," Calle said. "Leonov was a fellow artist, and we really hit it off very quickly. He helped me to get what I needed for my work, and we even visited art museums together. I was thrilled to be part of this joint effort. My space work started at the beginning of the NASA Art Program when our rivalry with the Russians helped produce the first manned flights in the 1960s. Now things were different. The sense of competition was gone. Now we were going to do this together."

The paintings and drawings produced by Paul Calle and other artists participating in the NASA Art Program were shown at the National Gallery of Art in two major exhibitions in 1965 and 1969. Most of this art toured the United States for several years under the auspices of the Smithsonian Institution. Some of it was shown in Europe and the Soviet Union. When the National Air and Space Museum opened its new building on the Mall in Washington in 1976, this work was part of the inaugural exhibition and is now part of that Museum's collection.

If Paul Calle had lived nearly 200 years ago, he probably would have traveled with Lewis and Clark through America's unmapped wilderness, recording in drawings and paintings the struggles of that band of intrepid explorers. When mountain man John Colter decided to leave the returning expedition and head into more uncharted territory, Calle probably would have accompanied him. And when Colter planted his foot in Yellowstone Valley for the first time, Calle would have documented that moment.

Paul Calle's work proves that this country is not only able to produce scientists, engineers, and astronauts capable of remarkable achievements, but also artists of equal ability—good company on a long and sometimes perilous journey.

James Dean
FEBRUARY, 1992

Apollo 11 blasted off at 9:32 on the morning of July 16, 1969. Launch Control radioed the crew: "Good luck and Godspeed." Armstrong replied, "Thank you very much. We know this will be a good flight."

The great voyage to the moon had begun.

I CONFESS THAT MY MEMORY is fading a bit, as I think back on what happened over 20 years ago. I certainly remember Apollo 11's thundering launch, the noise and fire from the gigantic machine blasting all other thoughts from my consciousness. I still remember vividly the sight of the distant earth, a tiny but incredibly beautiful blue-and-white beacon, beckoning me home. I remember the stark contrast between this jewel, our home planet, and the sterile rock pile we call the moon.

Alone in the command module, I did not see Neil Armstrong step out into the fine dust of Tranquility Base. I did hear Neil, and shared with millions back on earth a moment of immense pride as he said, "That's one small step for man, one giant leap for mankind." Paul Calle not only heard that, but in his mind's eye he saw it. Fortunately, Paul's eye is an exceptional one, and he transports all of us to the moon with Armstrong, to share this historic first human step on another planet.

We, in the American space program, have been fortunate to have had gifted leadership. James E. Webb was the Administrator of NASA during its formative years when we were building our lunar machines in response to President John F. Kennedy's clear goal of "landing a man on the moon and returning him safely to earth." Thomas O. Paine followed Webb and was NASA's leader at the time of Armstrong's first step. Both men understood clearly the place art has always had in documenting exploration. As Webb put it, "Important events can be interpreted by artists to give a unique insight into significant aspects of our history-making advance into space." Paine noted that "...we have a solemn obligation to leave for future generations a truthful record at all levels of perception, and for this the imagination and insight of the artist are invaluable assets."

I certainly share that view. As a photographer aboard Apollo 11, I certainly knew my limitations—and they are even more obvious to me today. Astronauts are skilled and highly trained observers. Most of us have been test pilots, and we are accustomed to remembering and recording the maneuvers of our airplanes. Our language, however, is highly technical. We speak of temperatures, pressure velocities, accelerations, vibrations. These yardsticks are of vital interest to the engineers, but beyond that—what was it really like in space? Our cameras were very good, but the finest emulsions are crude compared to the precision of the human eye. On film, colors fade, details blur. Astronauts are invariably disappointed after a flight to discover that what emerges from the photo lab is but a pale carbon copy of the view they remember. Furthermore, cameras are generally attached to the astronaut, and cannot retreat a few paces to view a scene with the ideal perspective.

At this point, enter an artist like Paul Calle. Whether working with pencil or brush, Paul combines the insight, the raw talent, and the highly developed technique that enable him to go beyond technology and present an image of the human spirit. For me, Calle's painting, *The Great Moment*, which depicts my friend, Neil Armstrong, combines the best of two worlds: NASA's technological achievements and an artist's exquisite interpretation.

Paul was with Neil Armstrong, Buzz Aldrin and me the morning of our launch, while we had breakfast in our crew quarters and during our suiting up at Cape Kennedy. In a sense he was equally at home with us on our trip to the moon. We took along with us a stamp die from the U.S. Postal Service, a Paul Calle design commemorating our flight. Issued in 1969, the *First Man on the Moon* stamp had a distribution exceeding 150 billion.

Paul understood what we were about on Apollo 11, and his magnificent work presents in a unique way the result of a gifted artist's creativity and skill.

Michael Collins
APOLLO 11 COMMAND MODULE PILOT

"Men's conception of themselves and of each other has always depended on their notion of the earth... To see the earth as it truly is, small and blue and beautiful in that eternal silence where it floats, is to see ourselves as riders on the earth together, brothers on that bright loveliness in the eternal cold—brothers who know now they are truly brothers."

ARCHIBALD MACLEISH

JOURNEY TO THE PAST

The Artist's
Portfolio

There was a time, deep in the woods, along icy streams and meadows, when trapper camps were filled with songs, stories and tales as trappers vied with each other to embellish the stories of the lives and loves of mountain men who roamed over the vast expanse of wilderness. When the day's work was completed, the long evenings and nights were spent in snug lean-tos around roaring fires as the trappers engaged in debates and friendly arguments in what was referred to as the "Rocky Mountain College."

The Storyteller of the Mountains
oil on panel, 35 ½" x 53", 1985

A chance meeting in a lonely high country pass sets the scene for my painting, *When Trails Cross*. Three trappers welcome the opportunity to rest their ponies as they eagerly swap stories and news of the fur trade.

But, days are short in the high country. Soon they will part, and only the sound of the chilled timberline breeze will remain as it echoes through the pass.

When Trails Cross
oil on panel, 36" x 51", 1984

S torm clouds giving way to sunshine is the setting for my painting as the trappers took "two from the flock" and laughed as the air was filled with startled, honking birds.

The trappers arrived at Bear River after an early spring snowstorm which left the trees and ground covered with snow. At this time of year, there were huge flocks of ducks and geese, and the trappers feasted on fowl and eggs.

Two From the Flock
oil on panel, 32 ⅛" x 51 ⅜", 1982

One of the most important voyageurs in each bark canoe was the *chanteur*, or singer, who led the songs as the voyageurs rhythmically paddled in time with the singing. While he was required to work as hard as any other man, he was of great importance and received extra wages. The songs he led were deliciously varied: hymns, patriotic ballads, love songs, both humorous and profane, all ending in a thunderous Indian war cry.

Another song rhythmically echoed across the lakes and rivers of that vast expanse was the sound of accompanying waterfowl. The journals of that period described them as the constant companions of the voyageurs, thus my painting, *Voyageurs and Waterfowl...Constant Companions*.

Voyageurs and Waterfowl...
Constant Companions
oil on panel, 34½" x 48", 1988

Nathaniel

Voyageur

Rounding a bend in the river, the voyageurs met with an unexpected delay. The swift-flowing streams now slowed into a series of increasingly shallow lakes, and the rocky bottoms of the shrinking streams posed a constant threat to the heavily laden canoe. This once clear waterway was blocked by a huge pile of logs formed by the spring runoff. The dwindling of the last stream forced the voyageurs onto a carrying place.

A narrow, sandy trail led through a pine forest. It was now necessary to unload the bales of furs, goods and supplies. Straining under the weight of their tumplines, the voyageurs carried a portion of their cargo, then returned for more, ending, finally, with the bark canoe. They repeated the process from stop to stop until they reached a clear flowing stream.

The Carrying Place
oil on panel, 22" x 32", 1985

80

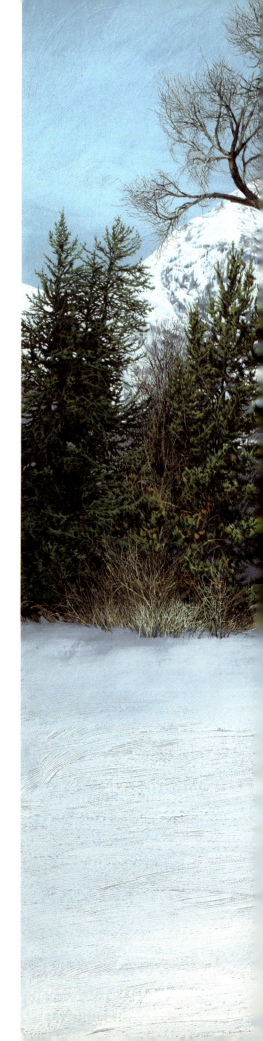

The air was crisp, the sky crystal clear as the lone trapper made his way down from the high country and across the Teton Valley. It had been a four-day ride since he crossed the Snake River, following the creeks and tiny streams searching for the mountain meadows rich with willow and aspen favored by the beaver. His pack animals, laden with fur and beaver pelts still wet from recent trapping, indicated that the trapping had, indeed, been good— so good that he was already looking forward to the great rendezvous at Pierre's Hole, even though it was still months away.

Out of the Silence
oil on panel, 33" x 48", 1992

Friend Bill

When the wagon trains carried the emigrants west along the Santa Fe, California and Oregon Trails, they often took their bearings from distinctive and prominent landmarks. While one could make a strong point that the most famous of the landmarks was Inscription Rock, there were others of equal importance, such as Independence Rock, Devil's Gate, Chimney and Castle Rock to name but a few. When the travelers caught sight of these prominent landmarks on the horizon, they were reassured that they were indeed on the proper trail west.

So it is in my drawing of a mountain man moving with his Indian wife from one camp to another; for him the huge tree serves as a familiar landmark, giving assurance that he is on the proper trail.

The Landmark Tree
pencil on paper, 30" x 40", 1980

*I*f the white man wants to live in peace with the Indian he can live in peace. There need be no trouble. Treat all men alike. Give them all the same law. Give them all an even chance to live and grow...

Let me be a free man—free to travel, free to stop, free to work, free to trade where I choose, free to choose my own teachers, free to follow the religion of my fathers, free to think and talk and act for myself—and I will obey every law, or submit to the penalty.

Chief Joseph, 1879

Hear Me O' Great Spirit
oil on panel, 24" x 16¾", 1984

Chief Joseph—Man of Peace
pencil on paper, 30" x 40", 1980
(reproduced here in sepia)

87

S ome time ago, at the invitation of my
Navajo friend and fellow artist, Jim Cody,
I had the opportunity to spend a good deal of
time wandering through Canyon de Chelly and
Monument Valley. Traveling by four-wheel
drive, we were able to visit with Jim's family and
friends in some of the more remote areas of the
Navajo homeland.

My painting, *Generations in the Valley,* is a result
of that trip. The painting symbolically portrays
the ties that countless generations of Navajos
have to their homeland.

Generations in the Valley
oil on panel, 32" x 52", 1977

In the late 1950s, while serving as Chairman of the National Parks Cooperative Art Program, I had the opportunity to visit several Hopi villages, one of which was Shongopavi, where I witnessed the sacred rain dance. Those visual memories remain etched in my mind.

Several years later, while doing research at the anthropological archives of the Smithsonian Institution in Washington, D.C., I came across some archival photographs of the Hopi villages I had visited. My stored memories were rekindled, resulting in two paintings of the Hopis, *Wood Gatherer of Walpi* and *Children of Walpi*.

Children of Walpi
oil on panel, 21⅛" x 38", 1974

90

Caring for the Herd
pencil on paper, 30" x 40", 1977

My painting of *The Grandmother* (right) was the result of one of many trips I took to Navajo lands several years ago. One late afternoon on a cold November day, I came upon this elderly woman wrapped in her blanket sitting in the sun in front of her hogan. I have tried to capture the feeling of sunlight as it fell upon the deeply etched lines of her face, contrasted with the soft wool of the blanket.

My drawing, *Caring for the Herd* (left), came about from a chance encounter with this Navajo woman, tending her goats and sheep, deep in Monument Valley. We spent the late morning and afternoon with her, sharing our lunch and water as we laughed and talked. There were also those precious moments of silence as we sat alone with our thoughts in the beautiful hushed silence of the valley.

The Grandmother
oil on panel, 24" x 18", 1975

An Indian's shield, while useful to deflect arrows, was thought of more as spiritual protection. His war bonnet was believed to confer on him supernatural powers of survival.

Although his face seems menacing, his eyes angry, his stance defiant, my painting of Chief High Pipe, with his horse and shield, reminds me of an Indian prayer:

> *O Great Spirit*
> *Whose voice I hear in the winds,*
> *and whose breath gives life to all the world*
> *hear me! I am small and weak, I need your*
> *strength and wisdom*
>
> *I seek strength, not to be greater than my*
> *brother, but to fight my greatest*
> *enemy—myself*

Chief High Pipe
oil on panel, 30½" x 40⅛", 1980

94

I n the high country, the free trapper was as independent as man is ever likely to be. Yet his independence was tempered by two dependencies: his rifle and his horse. As he searches the reaches of the Rockies' vast Bayou Salada below him where he plans to winter, the trapper seems to acknowledge his implicit reliance on his mare, already shaggy with her cold weather coat.

Companions
oil on panel, 16½" x 27", 1983

Ready to Fly

My painting, *Free Spirits*, exemplifies that moment when the mountain man, in his pursuit of beaver, climbed to the top of a high ridge and saw before him the mountains and valleys, that vast expanse of unexplored land, rich in streams, meadows and beaver ponds. This determined, self-reliant man lived in harmony with the land he inhabited with a freedom comparable to the free flying eagles of the sky.

Free Spirits
oil on panel, 33" x 30⅛", 1983

Indispensable to the expansion of frontier life, and more specifically to the Western fur trade, was the important role of the blacksmith. He played a vital part in the function of the far-flung forts and trading posts. Few were more valuable in various situations than the resourceful and proficient blacksmith. His skilled workmanship was necessary in the production of knives, hatchets, axes and beaver traps, and was vital in maintaining and repairing any that were damaged. Many blacksmiths were also quite adept at moving their anvils and forges to the camps of the fur trappers as they wandered over the great expanse of wild land.

The Frontier Blacksmith
oil on panel, 21" x 33½", 1985

M y drawing of *The Winter Hunter* (left) was inspired by some descriptive narrative in Osborne Russell's book, *Journal of a Trapper*. In my opinion, this may be the finest account of the life and adventures of the fur trappers in the Rocky Mountains, when the trade there was at its peak.

After completing the pencil drawing, I was fascinated with the possibility of creating an oil painting of the same subject. I became intrigued with the color relationship of the red wool capote against the white snow, the rough texture of the tree bark contrasting with the snow-covered pine trees and the warm gray feathers of the geese. It proved to be a challenging and satisfying experience.

Lacing the Beaver Peau

A group of free trappers, emerging from the solitude of a thick forest, crosses a cold, lonely mountain stream on their way to new trapping grounds. Soon they will be setting their traps…in search of beaver.

In Search of Beaver
oil on panel, 32" x 46½", 1983

Among the Aspen

The land and the rhythm of the seasons were forces that governed the mountain men's cycle of life.

One With the Land is that moment, high in the Absaroka Mountains, when the trapper paused and looked out over the mountain meadows, rich with aspen and willow, lonely creeks and streams, and knew there would be a plentiful harvest of pelts.

One With the Land
oil on panel, 33 ¼" x 43", 1981

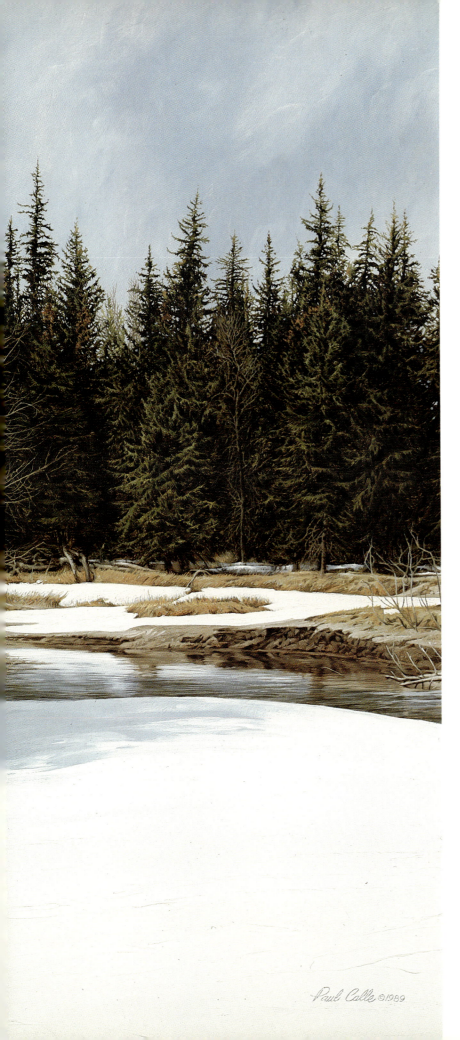

After spending the early morning hours setting his traps, the trapper came upon a small flock of Canada geese that had strayed from their flyway. I would imagine that after a regular diet of buffalo, deer and elk, a feast of fowl must have seemed like a rare delicacy.

Wrapped in his red capote to protect him from the cold of this early winter day, a red tuque upon his head and a colorful woven woolen *Salish* sash worn about his waist indicate that this fur trapper obviously had some contact with the voyageurs of the Hudson's Bay Company.

A Winter Feast
oil on panel, 28½" x 47¼", 1989

109

A Day's Ride to Camp

In the ever-expanding search for the finest beaver pelts, the trappers made their way down from the high country of the snow-capped Rocky Mountains into a land rich in streams and meadows—where eagles fly.

Where Eagles Fly
oil on panel, 43" x 56", 1989

110

Pascal

Caching his beaver pelts at the south fork of the Green River, the trapper headed for new beaver ponds. After a three-day ride, he knew that there would be a new day tomorrow, and he was…almost there.

Almost There
oil on panel, 18" x 27", 1991

Joshua - Mountain Man

And a Bear Claw Necklace

114

What of the men who went West in pursuit of furs? These were the men who blazed the trails, discovered passages through mountains, navigated unnamed rivers, lived with the Indians and, in some instances, adapted to their ways.

Theirs was a hard life, as related in this excerpt from Osborne Russell's *Journal of a Trapper [1834 - 1843]*:

I now began to reflect on the miserable condition of myself and those around me, without clothing provisions or fire arms and drenched to the skin with rain

I thought of those who were perhaps at this moment…seated around tables…collected in the gay Saloon…forgetful of cares and toils whilst here presented a group of human beings crouched around a fire which the rain was fast diminishing meditating on their deplorable condition…

These men lived their lives trapping in the lonely streams and meadows, and most died unknown, with their exploits, discoveries and stories unrecorded.

The Mountain Men
original hand-drawn lithograph, 30" × 22", 1989

While many of the mountain men and trappers hunted beaver in large company brigades of 50 to 60 men, there was another breed known as the "free trapper" who preferred working alone or in pairs.

His eyes mirror a soul engaged in a solitary enterprise, a man with a sureness born of perseverance, self-reliance and skill; a man with an education provided by nature, whose unforgiving lessons continually haunt his memory.

The Free Trapper
oil on panel, 32" x 48", 1986

I n his ever expanding search for fur, the trapper crosses over and down the snow-covered ridge and views for the first time the vastness of the distant valley below. He knows that he is about to enter into a place where he has never been before...he will be in the great alone.

Into the Great Alone
oil on panel, 42 ½" x 48 ¼", 1987

After checking his traps, the lone trapper was returning to camp along the now frozen lakes and ponds through the silence of the winter snow. The green grass had been transformed into a landscape of white, and winter had come as if the summer had never been.

The trapper came upon a small flock of Canada geese that had lingered too long before their flight south. This encounter provided him with something for his pot.

The Silenced Honkers
oil on panel, 22" x 30", 1991

Fate of the Late Migrant

Teton Friends
pencil on paper, 30" x 40", 1980

Abreak in a late afternoon search for beaver set the stage for my drawing, *Pause at the Lower Falls* (right). Always cautious, one mountain man keeps a watchful eye while his companion quenches his thirst in the cool mountain stream at the foot of the falls. Their horses, always important partners, take the opportunity to share in a refreshing drink.

My drawing, *Teton Friends* (left), should be viewed as symbolic of that time, in the early days of the fur trade, when many Indian tribes welcomed the small groups of mountain men to their lands. These early trappers respected the Indian customs and rituals, understood their values, and many adapted in varying ways to the Indian way of life. Thus, the mountain man became a creature in tune with the world he inhabited.

Pause at the Lower Falls
pencil on paper, 40" x 28", 1978

123

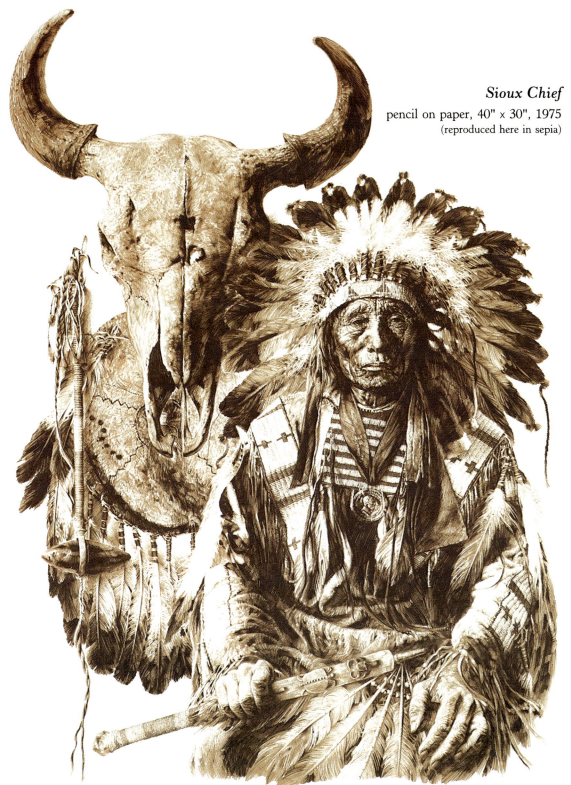

Sioux Chief
pencil on paper, 40" x 30", 1975
(reproduced here in sepia)

The ritual of pipe smoking was practiced by many Indian tribes during religious ceremonies or when men met in counsel, at solemn times and was also enjoyed socially. The custom often preceded trade with fur trappers and others and served as a symbol of peaceful intentions. In my painting, *The Breath of Friendship*, I tried to capture the spirit of communication in the sharing of the pipe ceremony.

The Breath of Friendship
oil on panel, 22⅛" x 25", 1982

125

Chief Wolf Robe

My painting of *In the Beginning…Friends* is symbolic of that time when the fur trade consisted of the trading and bartering of furs, with the indigenous Indian doing much, if not all, of the trapping of furs.

It was a time of harmony and friendship.

In the Beginning…Friends
oil on panel, 33¾" x 49", 1991

126

Religion was integrated in all aspects of the daily life of the Plains Indians. They viewed their very existence as dependent upon the willingness of the Great Spirit to bless and guide their endeavors. Prayers were offered to various heavenly bodies, animals, birds and rocks, in the belief that the Great Spirit, or God, would communicate through them.

In the vast stillness of a Montana landscape, a Sioux warrior, in full headdress, stands in the center of a sacred medicine ring full of rocks and skulls, hidden by the tall prairie grass. He prays to the Great Mystery in the hope that the buffalo will be plentiful for his people.

Prayer to the Great Mystery
oil on panel, 31" x 43", 1980

128

Chief Bear Ghost

You ask me to plow the ground. Shall I take a knife and tear my mother's breast? Then when I die she will not take me to her bosom to rest.

You ask me to dig for stone. Shall I dig under her skin for bones? Then when I die I cannot enter her body to be born again.

You ask me to cut grass and make hay and sell it and be rich like white men. But how dare I cut off my mother's hair?

Smohalla, circa 1830

Warrior No More

Son of Sitting Bull

My brothers, the Indians must always be remembered in this land. Out of our languages we have given names to many beautiful things which will always speak of us. Minnehaha will laugh of us, Seneca will shine in our image, Mississippi will murmur our woes. The broad Iowa and the rolling Dakota and the fertile Michigan will whisper our names to the sun that kisses them...

Eagle Wing, 1881

Chief of the Piegan Blackfoot

While mothers often made dolls for their daughters, it was the story of the granddaughter doll that caught my fancy. The custom of the Lakota Sioux was for the grandmother to create a doll for her granddaughter. When the granddaughter was old enough, the doll was used to explain the traditions and heritage of the tribe to the granddaughter and to tell her of her future responsibilities. These dolls were treasures that were cherished for life.

The Doll Maker

pencil on paper, 12 ⅞" x 14 ¾", 1983
(reproduced here in sepia)

Sioux Mother and Child

After a two-day ride from one camp to another, the free trapper emerged from the woods and thick pine forests into the solitude of a mountain meadow with its waving sea of golden grass. He knew he was almost there, and ahead lay a short ride to reach streams and meadows rich with beaver. He would soon be setting his traps.

Through the Tall Grass
oil on panel, 18" x 28", 1992

134

Mountain Man Gruff

After checking their beaver traps in the half light of dawn, the mountain men set out to hunt game in a high country valley protected from the cold winds of early winter. They came upon a group of mountain sheep which had come down from the rocky cliffs above their camp. Soon they would have enough meat to fill the camp pot.

Hunting the Bighorn
pencil on paper, 30" x 40", 1984

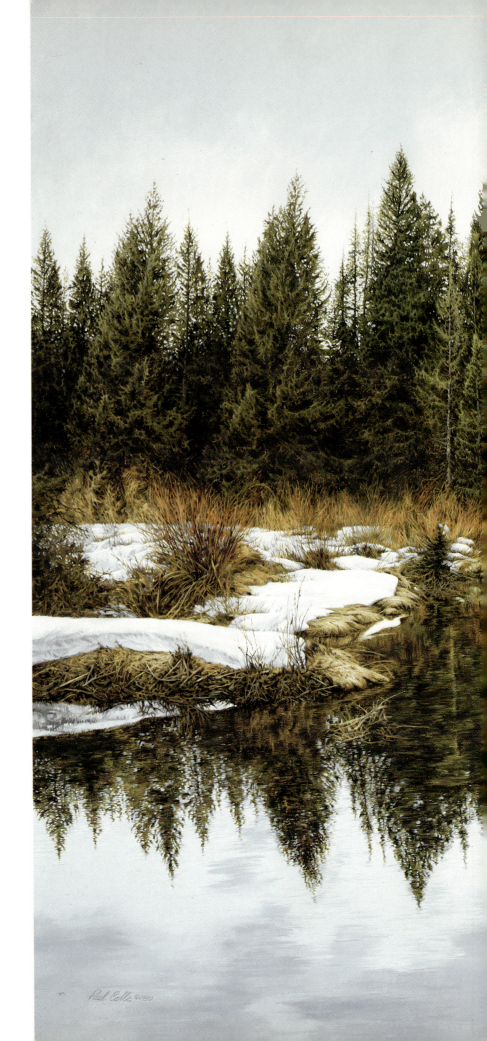

E merging from the woods into the solitude of a mountain meadow with snow still upon the ground, the trapper was returning to camp after setting his traps in the icy waters near active beaver lodges and dams.

The gray skies were giving way to sunshine as he came upon a small flock of Canada geese, whose early arrival was interrupted by his coming.

Interrupted Journey
oil on panel, 33" x 55", 1990

In order to obtain prime pelts, a trapper had to wait for the return of cold weather to trap the streams. He worked through the fall, starting at the higher elevations, working his way down, until the streams were frozen solid and the beaver holed up in their lodges beneath the ice for the winter. At such times, the taking of a Canada goose was a rare treat.

Hunter of Geese
oil on panel, 12" x 9", 1991

When Snow Came Early
pencil on paper, 30" x 40", 1978

W illiam was far from fulfilling the public image of a typical mountain man. Although his unruly beard was such that it would do honor to the chin of a grizzly bear, he was well educated with an insatiable appetite for literature, a knowledge of Latin and Greek and a keen understanding of history.

They Call Me William
oil on panel, 12" x 9", 1992

Morning Fog in the Mountains
pencil on paper, 30" x 40", 1974

After spending the early morning hours setting his traps in the icy ponds and streams near active beaver dams and lodges, the trapper returned to camp, rekindled the fire and awaited the return of his companions.

That night, gathered around a warm fire, they would have tales to tell of the day's adventures.

Return to Camp
oil on panel, 29 ⅜" x 45 ¾", 1982

Observing and tracking were critical to a trapper's survival. Each broken branch or twig at the edge of every clearing gave an indication of who or what had been this way recently. Hostile or brother trapper? Moving from one camp to another in search of beaver, a sudden snowstorm left the ground covered with snow and the trees heavily laden...resulting in my painting of *When Trails Grow Cold*.

When Trails Grow Cold
oil on panel, 36" x 60", 1990

146

Index to the Artist's Portfolio

112-113
*Almost There**
oil on panel, 18" x 27", 1991

114
Joshua-Mountain Man (left)
pencil on paper, 12" x 9", 1985

And a Bear Claw Necklace (right)
pencil on paper, 12" x 12", 1986

115
*The Mountain Men**
original hand-drawn lithograph, 30" x 22", 1989

116-117
*The Free Trapper**
oil on panel, 32" x 48", 1986

118
Man of the Mountains
pencil on paper, 12½" x 13½", 1985

119
*Into the Great Alone**
oil on panel, 42½" x 48¼", 1987

120-121
*The Silenced Honkers**
oil on panel, 22" x 30", 1991

121
Fate of the Late Migrant
pencil on paper, 12" x 9", 1983

122
*Teton Friends**
pencil on paper, 30" x 40", 1980

123
*Pause at the Lower Falls**
pencil on paper, 40" x 28", 1978

124
*The Breath of Friendship**
oil on panel, 22⅛" x 25", 1982

125
Sioux Chief†*
pencil on paper, 40" x 30", 1975

126
Chief Wolf Robe
original hand-drawn lithograph, 30" x 22", 1979

126-127
*In the Beginning…Friends**
oil on panel, 33¾" x 49", 1991

128
Spirit of the Buffalo
pencil on paper, 11" x 11⁵⁄₁₆", 1992

128-129
*Prayer to the Great Mystery**
oil on panel, 31" x 43", 1980

130
Warrior No More (left)
pencil on paper, 30" x 22", 1974

Chief Bear Ghost (right)
pencil on paper, 30" x 40", 1976

131
Son of Sitting Bull†* (left)
pencil on paper, 12½" x 14½", 1989

Chief of the Piegan Blackfoot (right)
pencil on paper, 22½" x 21½", 1991

132
The Doll Maker†*
pencil on paper, 12⅞" x 14¾", 1983

133
Sioux Mother and Child
pencil on paper, 16" x 23", 1991

134-135
*Through the Tall Grass**
oil on panel, 18" x 28", 1992

136
Mountain Man Gruff
pencil on paper, 12" x 12", 1986

137
Hunting the Bighorn
pencil on paper, 30" x 40", 1984

138-139
*Interrupted Journey**
oil on panel, 33" x 55", 1990

140
*Hunter of Geese**
oil on panel, 12" x 9", 1991

141
*When Snow Came Early**
pencil on paper, 30" x 40", 1978

142
*They Call Me William**
oil on panel, 12" x 9", 1992

143
Morning Fog in the Mountains
pencil on paper, 30" x 40", 1974

144-145
*Return to Camp**
oil on panel, 29⅜" x 45¾", 1982

146-147
*When Trails Grow Cold**
oil on panel, 36" x 60", 1990

149
The Old Trapper
pencil on paper, 12" x 12", 1984

151
*Friends** (Detail)
oil on panel, 16" x 20", 1981

*These works, as well as others by Paul Calle, have been published as limited edition art prints by Mill Pond Press. For more information contact:

In the United States
Mill Pond Press, Inc.
Dept. PC
310 Center Court
Venice, FL 34292-3500
800-535-0331

In Canada
Nature's Scene
976 Meyerside Drive
Unit 1
Mississauga, Ontario L5T 1R9
800-387-6645

† These pencil drawings were reproduced in sepia as limited edition prints by Mill Pond Press.

PAUL CALLE — AN ARTIST'S JOURNEY
was produced by the Book Division of Mill Pond Press
under the direction of Laurie Lewin Simms.

DESIGN AND ART DIRECTION
 David Skolkin

PROJECT MANAGER
 Nicki Watts

PROJECT COORDINATOR
 Linda D'Agostino Clinger

EDITOR
 Dana Cooper

ADVISOR
 Ellen Pedersen Collard

PRODUCTION SUPERVISOR
 Phyllis Stewart

PRODUCTION ASSISTANCE
 John Mabry
 Ken Higgs
 Jeni Dettman
 Mary Nygaard

PRODUCTION PHOTOGRAPHY
 Hans Kaczmarek, German Master Photographer

COLOR SEPARATIONS
 Lanman Lithotech

PRINTING
 Central Florida Press

BINDING
 Rand McNally Book and Media Services